Treasured Legacies

Treasured Legacies

Older & Still Great

text and photographs by

Irene Borins Ash, M.S.W., R.S.W.

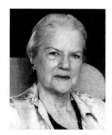 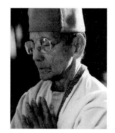 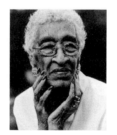 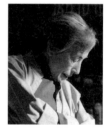

Second
Story
Press

NATIONAL LIBRARY OF CANADA
CATALOGUING IN PUBLICATION

Ash, Irene Borins, 1952-
Treasured legacies / Irene Borins Ash.

ISBN 1-896764-78-9

1. Aged—Canada—Biography. 2. Aged—United
States—Biography.
3. Aged—Conduct of life. I. Title.

HQ1060.5.A83 2003
305.26'092'271
C2003-905169-2

Designed by Counterpunch/Peter Ross
Printed and bound in Canada

*Second Story Press gratefully acknowledges the support of
the Ontario Arts Council and the Canada Council for the
Arts for our publishing program. We acknowledge the
financial support of the Government of Canada through
the Book Publishing Industry Development Program, and
the Government of Ontario through the Ontario Media
Development Corporation's Ontario Book Initiative.*

Published by
SECOND STORY PRESS
720 Bathurst Street, Suite 301
Toronto, Ontario, Canada
M5S 2R4

www.secondstorypress.on.ca

DEDICATION

This book is dedicated to my husband, Irv Ash, for his never ending support and patience, and to my late grandmother, Dorothy Ludwig, who led her life with wisdom, grace and dignity, and who left a legacy for others to follow.

ACKNOWLEDGEMENTS

In the process of researching and writing this book, I became acutely aware that as people age they can continue to lead a vital and productive life filled with joy and energy – despite life's difficulties. The women and men whom I have met are courageous and offer us all a sense of hope in the aging process.

I would like to thank everyone I interviewed and photographed for this book, both those who appear in the book and those who appear only in the travelling exhibit. All of these people allowed me to formulate my conclusions and helped to make this book a reality. The time and energy they spent with me was a gift. I cannot express my appreciation enough.

I would especially like to thank my husband, Irv Ash, for being a true partner in every sense of the word in helping make this book possible. Although Irv is a professor, he became my "techie" and helped with setting up photo equipment, as well as with some of the interviewing and writing. I would also like to thank my mother, Beverley Borins, for her continual support and for being the kind of person who is a positive example for all who are lucky enough to get to know her.

I would particularly like to thank my photography associate and friend, Gadi Hoz. He was very generous and patient in sharing his expertise with me. David Bender, Chris Switzer and Taralea Cutler Ridout were also very helpful in their knowledge of photography.

A special thanks to Stuart Razin, the National Director of Canadian Friends of Yeshiva University, and Dean Sheldon Gelman of the Wurzweiler School of Social Work, for their interest in my project.

I would like to thank all of my friends and colleagues who believe in my project/passion and who stood by me when I wondered why I was continuing to collect images and thoughts.

Swami Pramathananda was a true inspiration for me, and he passed away just prior to the book's completion. He leaves behind a large congregation of devotees and admirers who have benefited in many ways from his teachings, counseling and personal example. His spirit and wisdom will live on.

A warm thanks to Ethel Raicus for introducing me to my publisher, Margie Wolfe. They are both very unique and special women. Thanks also to the staff at Second Story Press, especially Laura McCurdy, for their editorial input and hard work.

INTRODUCTION

With North Americans determined to stay young forever, few of us really believe that getting older means getting better. Rather, the elders of society are seen as a drain, contributing little to the larger community and consuming valued resources.

As a social worker in both institutional settings and community-based agencies for sixteen years, I met hundreds of seniors. True, some have been depressed and despondent, leading painful lives even with good health, but many are dynamic and truly revolutionary in their approach to living and aging.

In particular, many of the women I have met — who are alone either by choice or who are widowed — have found new challenges and new relationships, and are looking at the world with a new sense of freedom. Often these women are more open to the breadth of life's experiences, more tolerant, and more concerned about the community around them than they had been when they were younger. Some have become so passionate about issues that they involve themselves with causes of social justice, even organizing demonstrations. Others begin studying for the first time in decades, and those perhaps confined by ill health seem to develop rich internal lives, full of wonder and creativity. Many who have been active all of their lives continue their work the best they can. These women are definitely not pathetic little old ladies. The sweet grandma has been transformed into the "raging granny," and what a wonderful sight she is.

One can't help but wonder why some are aging so creatively while others seem to simply fade. In my immediate family my father and his mother led unhappy lives in their later years while my own mother and my maternal grandmother led rich and rewarding ones despite numerous health problems and losses. As a young girl, I was curious about the difference. When I entered the health professions, exploring the issue became a special passion.

As a social worker, I presented papers at the Baycrest Centre for Geriatric Care (1994) and the Ontario Gerontology Association (1999), both in Toronto, and at the Fourth Global Conference of the International Federation on Aging (1999) in Montreal. These papers all focused on positive and dynamic aging despite life's difficulties. In my presentation for the Ontario Gerontology Association, I talked about seven seniors who were inspiring in their approach to life. Preparing to give the same paper in Montreal, I decided to photograph

these seniors. I have been an amateur photographer since my teenage years, so this was a natural progression. Most people who attended my workshop were intrigued not only by the text presented, but also by the photographs. Seeing an image of the person seemed to help them connect not only intellectually but also emotionally to that person.

These seven camera portraits became the foundation of my first exhibit of photographs, displayed at the Koffler Gallery in Toronto. The exhibit, which included photographs and thoughts of forty people, was entitled "Life Journeys – An Exploration through Images & Thoughts," and was shown from November to December 2000.

At the opening of my next exhibit, entitled "Treasured Legacies" and held at Holy Blossom Temple in Toronto from August to September 2002, the legendary Oscar Peterson, one of my subjects, spoke about "Creativity & Aging." My third exhibit, by the same name, was held in the rotunda at Toronto City Hall in June 2003. All three shows were attended by thousands of people, and were part of the journey of discovery that led to this book.

One of the key factors in aging well is learning to adapt to change. Part of adjusting to major life challenges, and to loss, is accepting them as a normal part of the aging process. It is critical for all of us to develop inner resources to help us adjust to change and loss, and to

struggle to redefine ourselves in light of such events. For many of us, retirement and old age may be about creating a new life. It can mean viewing the world from different perspectives and doing things we have never tried before.

While I was preparing my research, many younger people said to me, "If you have your health and you have money, you can age well." However, some of the people I interviewed do not have the best health, and do not have much money, yet they are living richly inventive lives. They are not concerned about their gray hair and deepening wrinkles. People like these – the people in this book – are not a drain or a burden on others. They are contributing to society. Their approaches to aging are in many ways revolutionary. They are an inspiration to the rest of us, who can learn from them how to be strong and positive in our own later years.

What are the lessons imparted by these elders? Some common features of people who age well, which apply to most of the subjects I interviewed, are as follows:

- They are connected to family, friends and community. They are not self-centered; they focus on the world around them instead.

- They are compassionate; the most contented people reach out and give to others.

- They are passionate about something, or about many things. Often, they do volunteer work. They use skills they have acquired over a lifetime, and act as consultants or mentors to teach younger people.
- They are aware and concerned about political and social issues.
- They strive to do their share, no matter how small or great, to leave the world a better place after they are gone.
- They keep wanting to learn. For them, life is about wonder, and about using learning to teach others.
- They have developed a keen sense of humor. They can laugh at themselves and at life in general.
- They have come to accept their limitations and weaknesses, and have learned to live rich, full lives despite their frailties.
- For some, spirituality is a vital part of life. It helps them weather disaster and loss.
- They have come to terms with their past anger and pain, and developed insight from their struggles.
- They have come to accept their own mortality. Their awareness of life's finite nature helps them to live each day with purpose and meaning.
- Most try to keep as active as their physical limitations allow.

Elders can and should serve as bridges between generations. The wisdom, values, compassion and concern for humanity that they have acquired over a lifetime of experiences enable them to leave a wise legacy. They can find or create a purpose for living that is stronger than whatever physical or mental disabilities may slow them down. They can teach us to focus on celebrating both similarities and differences in our diverse society. They are our "treasured legacies."

We all have an infinite capacity to support and show concern for others. In our younger years, we are often too stressed and harried to see much beyond today's errands or tomorrow's meetings. The elders in our midst, whose perspective covers so many years, can help us to find a longer, clearer and broader vision of life.

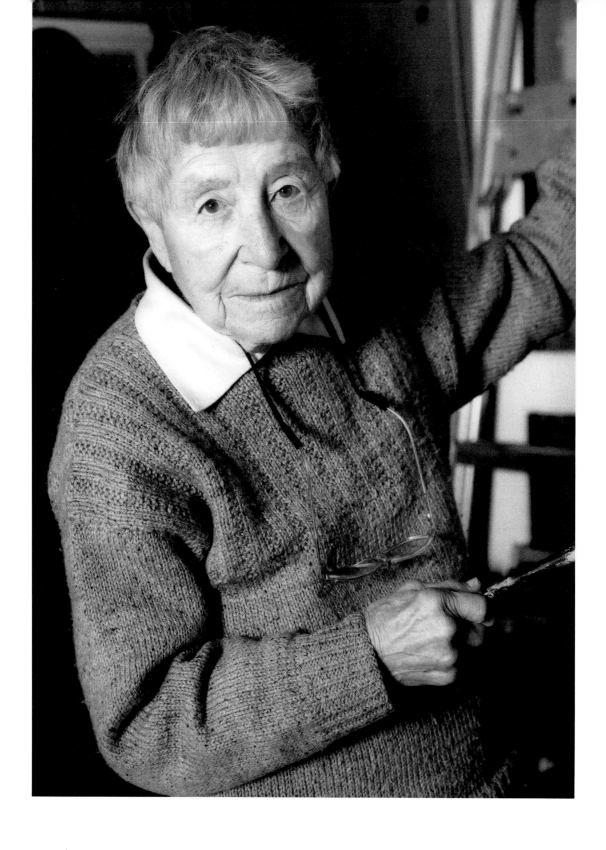

Doris McCarthy

Artist, teacher, traveler, Member of the Order of Canada and the Order of Ontario.
Born in 1910 in Calgary, Alberta, Canada.

Doris McCarthy has found that life has improved as she has grown older. She believes that hard work is the secret to her good health. She also feels that there is a freedom in old age, and that it is never too late to begin to explore creative possibilities. Certainly she has developed a few creaks in her ninety-plus years, but they have not affected her joy in life.

The three aspects of that joy are people (first), work (very close behind), and a daily-increasing awareness of the miracle of nature and the beauty of the world.

Doris's life has been rich in friendships. She learned young that there is no limit to a person's capacity to love, and that every friend is unique and precious. Growing old means that she has also learned to accept the death of some of those dear to her, but there are always younger people eager to be welcomed into the warmth of friendship.

Doris's work as an artist and teacher has kept her constantly challenged and stimulated. She taught high school art for forty years, spent time studying in London, England, and has traveled and painted all over the world, capturing the beauty of natural landscapes in her evocative oil paintings. Recently, she had the satisfaction of seeing her work gain public recognition. She was delighted to be made a Member of the Order of Canada and of the Order of Ontario, and has accepted with gratitude other honors as well.

Doris lives without fear. "How could anyone have imagined the beauty and complexity of nature, which scientists are slowly uncovering?" she says. "How can we hope to imagine the life into which death will admit us?"

Helen Levine

Feminist, social worker, professor of Women's Studies, recipient of the Governor General's Award in Commemoration of the Person's Case for advancing the equality of women in Canada, wife, mother, grandmother. Born in 1923 in Ottawa, Canada.

Helen Levine has searched for meaning and a sense of social purpose for much of her adult life. She found it in feminism, which still defines, challenges and inspires her.

Growing up in a conformist society, she initially followed the prescribed life plan for women of her era. She married and had two daughters while employed as a social worker.

Then, in the early 1970s, Helen had a breakdown and spent months in a psychiatric hospital. The "breakdown" became a turning point in her life. She documented her experience in a diary, part of which was published in her groundbreaking work, "The Personal is Political: Feminism and the Helping Professions."

She critiqued traditional marriage, motherhood and the family. She attacked the conventional assumptions and practices of psychiatry and the helping professions. And she exploded the dominant myth that women's personal struggles emanate solely from individual circumstances or deficits.

Helen was instrumental in bringing a feminist analysis into the curriculum of Carleton University's School of Social Work and beyond. In Ottawa, she helped establish community counseling services for women and the city's first battered women's shelter. She is a member of The Crones, a support group of older women.

As an old woman – she likes being called that – Helen continues to be actively engaged with women's struggles for full human entitlement.

But there are changes. Helen revels in a delicious sense of freedom from social constraints. She doesn't much care anymore about how other people think she should behave. There is much more fun and laughter in her life. Her friendships – with young and old – are now deeper, more varied and more integrated into her life. Some of her richest, zaniest times are spent as one of "the Levine foursome," with her husband and two daughters.

Tennis and biking have been replaced by yoga, aquafit and a gentle stretching regime. Despite arthritis and physical limitations, Helen is grateful for the mobility and coordination she still has. She accepts and cares for her body as it is.

At eighty, Helen has a sense of achievement, and a philosophical acceptance of the aging process. She looks back on an interesting – though sometimes painful – life with a sense of finally having come home to herself.

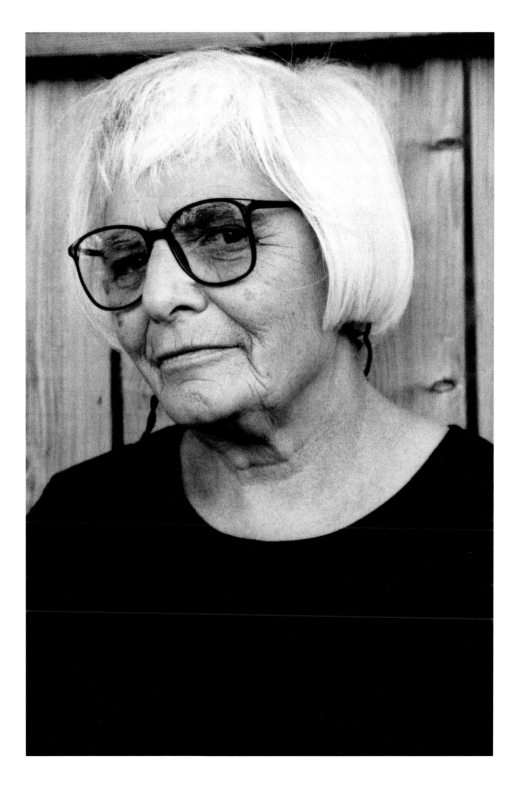

Siva Gnanaratnam

Counselor, mother, grandmother. Born in 1927 in Matale, Sri Lanka.

Siva Gnanaratnam has had colon cancer for over ten years. She is part of a pilot project testing a drug that helps people live with the cancer, in the hope of adding years to her own life as well as helping others, both during her lifetime and after she is gone. She believes that the combination of medication and a positive attitude is keeping her alive.

Siva's family are Tamils, an ethnic group from India and Ceylon. Siva had a wonderful mother who died when Siva was sixteen. Siva was married at eighteen, and came to Canada in 1974. She worked as a cashier at IBM for eighteen years, and has always kept herself busy and active in the community. Siva believes that her mother and father instilled in her the conviction that she should be of service to other people, and she has worked with Tamils who are new to Canada, helping them integrate into Canadian society. She also counsels other people who have colon cancer. When she has the time, she prepares food for her neighbors. She also enjoys feeding her family; her husband died several years ago, but three children, six grandchildren and two great-grandchildren keep her on her toes. Through helping others, she is convinced that she helps herself.

Religion has also supported Siva through her ordeal. She believes that her illness has actually given her strength, and that she will be at peace when her time is up. Even when we are sick, Siva feels that we should "keep doing" and not waste time. "JUST DO!" she says. "Time never comes back to you!"

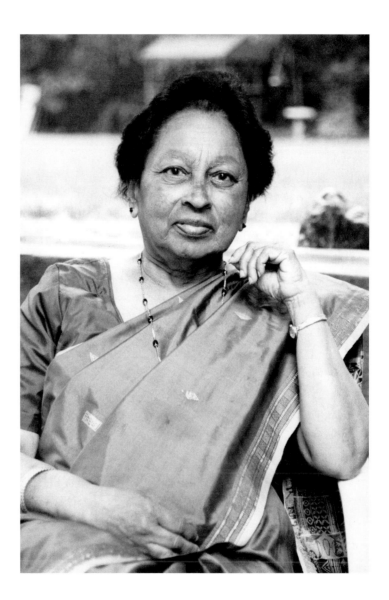

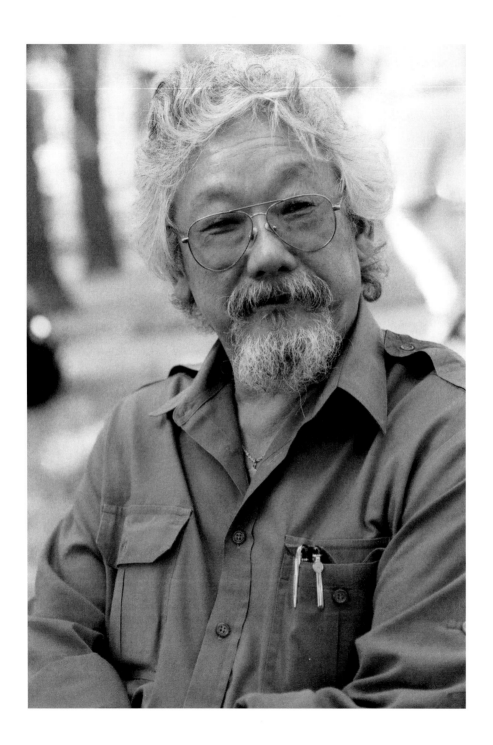

Dr. David Suzuki

Scientist, professor, speaker, environmentalist, human-rights activist, Officer of the Order of Canada, author, broadcaster, journalist, husband, father. Born in 1936 in Vancouver, British Columbia, Canada.

David Suzuki is a third-generation Canadian of Japanese origin. During World War II, he and his family were denied the rights of citizenship because of their race, and uprooted and incarcerated in a remote valley in the Rocky Mountains. The experience fostered his lifelong commitment to opposing injustice and bigotry, and to promoting tolerance and human rights. It also instilled in him an abiding love of nature.

David has supported numerous civil-rights causes, including battles for the rights of First Nations in Canada, of indigenous people in many other countries, and of people of color, gay people and citizens of impoverished developing countries.

David's fascination with nature, which was influenced by his father's keen interest in the natural world and by the attitudes of Canada's First Nations, led him into an academic and research career in science. He earned a PhD in genetics from the University of Chicago and became a professor at the University of British Columbia. Knowing that genetics had been misused in eugenics programs in Germany (and other countries, such as the U.S. and Canada) early in the twentieth century, and had led to the Holocaust, he spoke and wrote extensively about how this science has been and is still misused in such areas as genetic engineering and cloning.

David has worked in and reported on most parts of the world. His broadcasting career, both in radio and television, has involved him in hundreds of programs broadcast in numerous countries for more than thirty years.

David's focus on important environmental issues around the world led to the creation, in 1989, of the David Suzuki Foundation. One of its key interests is the major role that the knowledge and perspective of elders around the world should play in our efforts to achieve a sustainable future. The following quote encapsulates his thoughts on the subject:

"Elders today are a living record of enormous change that has happened over the past century. They provide an important counter to the widespread notion that 'newer is better' and 'more is best.' Tradition, community, family, these words have important meaning that elders know. A society that doesn't treasure the knowledge, experience and wisdom of the elders is in trouble."

Mayor Hazel McCallion

Mayor of Mississauga, Ontario, Canada, American Woman of the Year, holder of the Cross of the Order of Merit of the Federal Republic of Germany, feminist, social advocate, mother, grandmother. Born in 1921, in Port Daniel, Quebec, Canada.

Hazel McCallion has been breaking new ground in politics for over three decades. In 1967 she became the chairman of the Streetsville Planning Board, moving on through the positions of Deputy Reeve, Reeve and then Mayor of Streetsville. As well as the city's first woman mayor, she was the first woman president of the Streetsville and District Chamber of Commerce. In 1978 she became the first woman to be elected Mayor of Mississauga. She is also the longest-serving mayor in the city's history.

Hazel has been an innovative and hard-working, if sometimes controversial leader. She made her municipality's annual operating budget available to the public, and implemented a pay-as-you-go policy that eradicated the city's debt. She has sat on almost every committee in her region and on provincial panels to assess government services, and was elected Chair of the Central Ontario Smart Growth Panel in 2002. An outward-looking mayor with an international presence, she chaired a World Health Organization symposium on Healthy Cities and served as vice-president of the World Conference of Mayors. Her activities have earned a great deal of recognition, from Germany's highest individual honor for her role in bringing German business to Canada, to a listing as an "American Woman of the Year" in the publication *Who's Who of American Women* (which includes all North Americans). She has also received several humanitarian awards.

In addition to politics, Hazel is active on a more personal level. Spirituality is very important to her, and she was the first woman president of the Anglican Young Peoples' Association of Canada. Hockey is also a passion of hers. She played in a top women's hockey league in the 1940s, and, still keen on supporting women's involvement in the game, was three times the honorary chair of the Women's World Hockey Tournament. She enjoys fishing and spending time with her three children and her grandchild (her husband passed away in 1997).

A tremendous amount of Hazel's personal satisfaction comes from helping other people. But she also strongly believes that people should empower themselves by being as self-reliant as possible, taking responsibility for their mental and physical health. Her philosophy can best be summed up as "If you give the best to what you do, the best will come back to you."

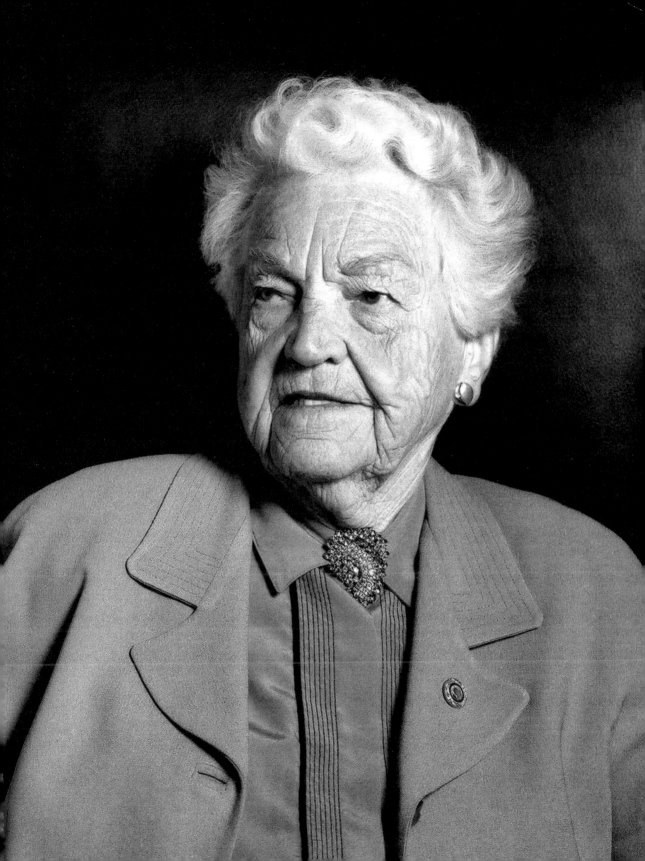

Celia Franca

Dancer, choreographer, teacher, narrator, first director of the National Ballet of Canada, co-founder of the National Ballet School, co-artistic director of the Ottawa School of Dance, recipient of the Centennial Medal, Companion to the Order of Canada, the St. George's Society of Toronto Woman of the Year. Born in 1921 in London, England.

Celia Franca was born to a family that was not generally creative, but she always wanted to move or dance. She remembers being at a wedding reception at the age of four and dancing by herself; the conductor of the band told her mother that the girl should take up ballet. Although Celia had never heard the term before, she began pestering her parents for lessons. By her fifth birthday she was at London's Guildhall School, on scholarship, learning music, dance, theater and elocution — as well as the self-discipline and respect for excellence that have been the hallmarks of her career and her life.

At the age of fourteen, Celia quit school to dance professionally, to prove to her father that she could; he had thought she would never earn a living as a dancer. In the 1940s, she carved out a career as a dramatic solo dancer, ballet mistress and choreographer in various institutions and companies in England.

In 1950, at the height of her fame in her native country, Celia was asked to come to Canada to start a classical ballet company from scratch. She did so in ten months, supporting herself by working as a file clerk in a department store as she recruited and trained dancers, staged concerts, organized a summer school, gathered an artistic staff and got the whole company ready for its opening in November 1951. She remained director of the National Ballet of Canada until 1975, while it gained renown as a major ballet company and brought over thirty Canadian ballets into its repertoire.

In 1959 Celia and ballet mistress Betty Oliphant co-founded the National Ballet School in Toronto, to help supply Canadian-trained dancers to companies around the world. Celia has been a sort of mother figure to many young artists seeking her wisdom, and has often been involved with other educational and artistic institutions, to give back to Canadian society. She is passionate about the need for ballet in Canada and all countries.

Celia has always done what she felt she should be doing, and is driven to do it well. Her training, working and teaching in dance have provided her with many life lessons, which she passes along to her current students at the Ottawa School of Dance. She is "having a ball," still busy living life to its fullest. Her third husband died after thirty-two happy years of marriage, but she has a companion to do things with (though they live apart). She is not afraid of dying — she is just not ready right now.

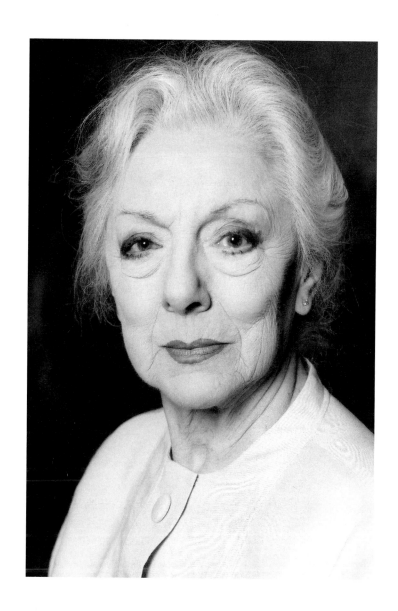

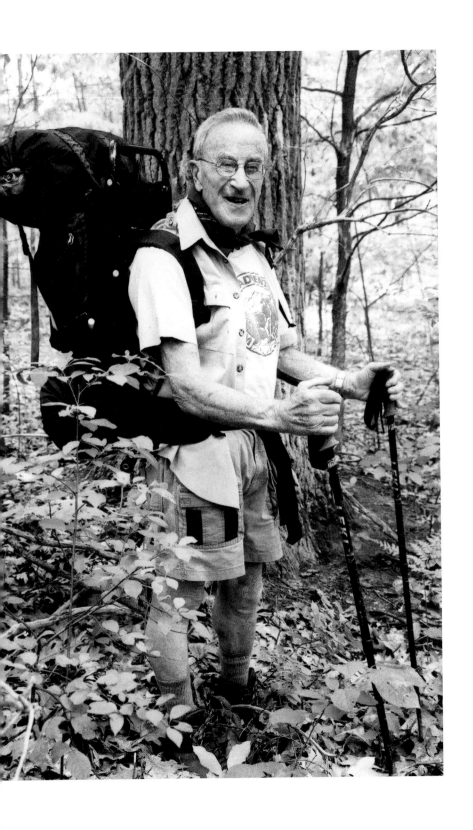

Willard Kinzie

Entrepreneur, hiker, mountaineer, husband, father, grandfather.
Born in 1919 in Cambridge, Ontario, Canada.

Willard Kinzie was raised in a Mennonite area with a very strong community. There he learned the importance of being helpful to others, and of using social skills to develop a sense of closeness and support. One of the reasons he is now so passionate about leading hiking tours is that he can help form his group into a little community, during and even after the tour.

Willard owned a creamery business for many years, producing butter, cheese and ice cream. When he was in his early forties, however, he began to experience severe back problems. He decided to sell the creamery. On the advice of his doctor, he started walking.

Willard initially hiked the Bruce Trail, a pathway 450 miles (720 kilometers) long that starts near Niagara Falls and runs up the Bruce Peninsula, between Lake Huron and Georgian Bay. Then he began to lead hiking groups and went on to start a business called "Willard's Adventure Club," where like-minded people of all ages could hike many trails throughout North America. He explains that when people belong to a hiking club and share their adventures, they have a chance to experience a wonderful sense of camaraderie. He finds that peoples' true personality and character come out in the challenging environment of hiking. He has also noticed that people on a hike naturally turn to him with their problems and concerns, as he is usually the oldest person there. When he is hiking, any barriers of age disappear; he has often hiked with his children and grandchildren.

Willard says that the natural beauty one encounters on an expedition can be spiritually overwhelming. He finds that one of the biggest benefits he receives from hiking is the ability to forget about his day-to-day problems and to reflect instead upon past experiences that have brought him joy – an enlightenment that helps him understand himself better.

Willard spent his seventy-ninth birthday on Mount Kilimanjaro, the highest mountain in Africa. He continues to hike enthusiastically, spending his summers leading groups with his grandchildren, who come along to assist him.

Doris Anderson

Feminist, writer, editor, Companion of the Order of Canada, recipient of the Lifetime Achievement Award from the Canadian Journalism Foundation, president of Fair Vote Canada, past chair and past president of the Canadian Advisory Council on the Status of Women, past chancellor of the University of Prince Edward Island, mother. Born in 1921 in Calgary, Alberta, Canada.

After Doris Anderson's mother was deserted by Doris's father, she and Doris's grandmother ran a boarding house to support themselves. Doris claims that those early years when women ran her small world turned her into a feminist.

Although there were high expectations for her brothers, Doris was simply expected to marry, preferably to a man with a good, steady job. Yet her grandmother and two aunts had been widowed and had raised children quite competently, and Doris resolved not to be wholly dependent on a man. In her autobiography, *Rebel Daughter*, she writes, "As I approached my teens, I grew more and more apprehensive. I had watched feisty, active girls suddenly, on reaching adolescence, turn into giggling simpletons. I determined that I was not going to be one of them."

The depression made life even more difficult for the family. During this time, teachers, especially female teachers, had a strong influence on Doris. All of them were spinsters, because during the Depression any woman teacher who married lost her job. Some of them were early feminists, and they encouraged Doris to think of going to university, even though there was almost no financial assistance to help her. Doris became a teacher, taught in rural schools and saved her money, and earned her BA from the University of Alberta.

When she graduated in 1945, she bought a train ticket to Toronto to pursue a career in journalism. She held a variety of minor jobs — the war was over and most jobs were being kept open for men — but she finally landed a job at *Chatelaine* magazine. She went on to become the editor, a post she held for twenty years. Her lifelong commitment to the women's movement motivated her to give her readers something to "shake them up"; she included articles on such issues as the legalization of abortion, battered babies, female sexuality, racism and the plight of Canada's Native peoples. She married in her thirties, and had three sons.

Doris says in her autobiography, "Although it's hard to be cheerful about aging in our youth-obsessed culture, I've found that growing old has many advantages. Long ago I gave up high heels, downhill skiing, trying to make a passable pie crust, and worrying about balancing my bank account to the cent. Finally I am able to smile at a man with no fear that he may interpret it as a pick-up!"

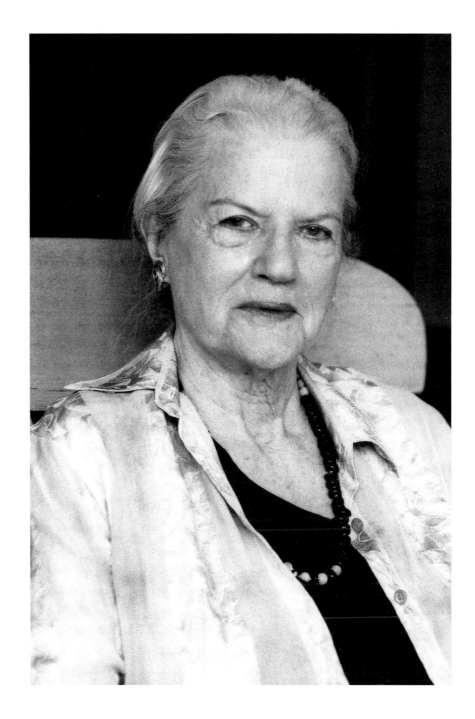

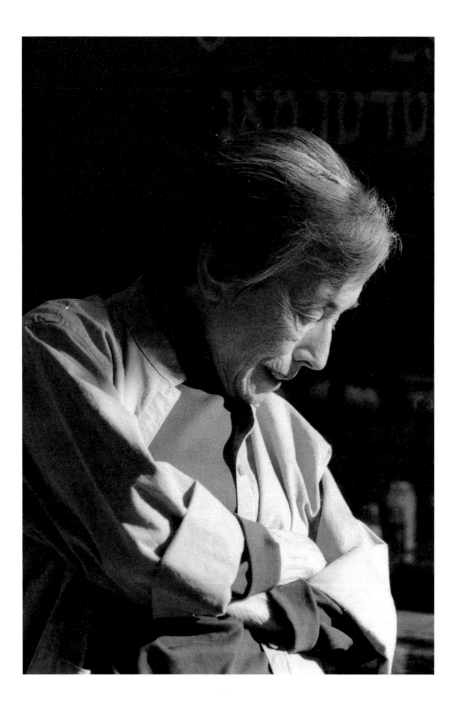

Ethel Raicus

Painter, designer, art instructor, past director of the Hebrew Department at Holy Blossom Temple, Jewish educator, editor, translator. Born in 1920 in Toronto, Ontario, Canada.

Ethel Raicus was born to an immigrant family and has lived in Toronto for most of her life.

Her parents separated when she was six and Ethel was brought up by her mother. They were living above a butcher shop, and the butcher and his wife, themselves hard-working immigrants, kept an eye on Ethel while her mother worked. She in turn oversaw the violin practice of their gifted five-year-old. Maintaining the boy's interest was her first teaching challenge. Ethel had loved the violin, sight and sound, from earliest memory.

In those days, when meat parcels were outer-wrapped in newspaper, there was always a pile of papers on a table ready for use. Ethel would come down after store hours to rummage, select and clip. If the caption said "famous" or "great" the photo was chosen: of a painting or painter, a dancer, athlete, politician, actor, musician, scientist. Some of the clippings went into scrapbooks that she cherishes to this day.

Ethel attended after-school classes in Jewish history and Jewish and Hebrew literature, and took Saturday morning art classes at the Art Gallery of Toronto (now the Art Gallery of Ontario). From 1948 to 1950 she ventured abroad to work in a kibbutz and teach in a children's village in the newly established state of Israel.

In 1953 Ethel became the first woman to graduate as an industrial designer from the Ontario College of Art. She is a member of the Canadian Society of Painters in Watercolour and of the Ontario Society of Artists, is represented in many collections and has received numerous awards. She has taught design and painting at Queen's University, at the University of Guelph and in the Toronto area community, to both youth and adults. As well, she was on staff at Holy Blossom Temple for thirty-five years, teaching Jewish studies and Hebrew.

In her seventies, Ethel went off to Oxford University to hone her skills in Yiddish. She brought her passion for the language to *Found Treasures: Stories by Yiddish Women Writers*, a groundbreaking book project in which she played a pivotal role as a translator and editor.

It seems to Ethel that the adjective "old" is conferred upon people too freely, often unrelated to their perceptions of themselves or their ability to function. The skills and experiences acquired over a lifetime can make the later years the richest period in someone's life.

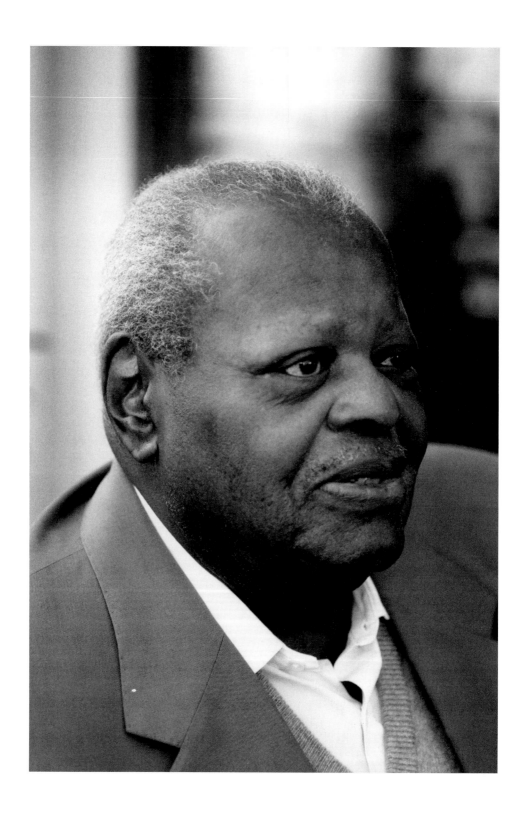

Oscar Peterson

Jazz pianist, Companion to the Order of Canada, holder of numerous other awards, advocate for civil rights, photographer, husband, father, grandfather. Born in 1925 in Montreal, Quebec, Canada.

Oscar Peterson is regarded by many as the greatest jazz pianist in the world today. He was performing on radio by the age of fifteen, had his own trio by the time he was in his early twenties, and went on to compose and record numerous pieces, including several suites and a film score, and to teach music at Toronto's York University. His work has been described as an historic and enduring legacy within the Canadian experience.

Oscar is a very spiritual person. Family is also very important to him. While other musicians were turning to drugs to help them cope with life on the road, Oscar's family teachings and values sustained him. His belief is that parents leave an impression on their children that time cannot erase.

Oscar has focused mostly on music, letting his own excellence make the case for racial equality. In the 1980s, however, he used his influence to open up advertising to minorities. He was especially disturbed that non-white children saw nothing but white faces in print and on television. "It was a blatant affront to all the races that make up the fabric of Canada," he said.

Oscar feels that it is often harder to accept the aging process when you have been highly successful, as you cannot do what you had done previously. Due to his health, he is unable to do some things he did in the past, but he can do different things now. He still draws large crowds to hear him on the piano, which he has played with one hand ever since his stroke. He also retains his lifelong passion for photography, and has captured remarkable images of his career as a jazz musician. He says people "can continue to make changes that allow them to adapt to the present and also they can take on new interests." He believes that "it is important to be able to accept who you are day to day." He adds, smiling, that he can still say what he needs to say musically.

Mona Winberg

Writer, advocate for people with disabilities, Member of the Order of Canada, holder of the Queen's Jubilee Medal, Rotary International Paul Harris Fellow, affectionate aunt. Born in 1932 in Toronto, Ontario, Canada.

Mona Winberg was born with cerebral palsy, which left her with little hand coordination, slow halting speech and somewhat impaired hearing. Throughout her growing-up years, her mother instilled in her a desire to be independent so as not to be a burden on anyone. This training stood her in good stead when her mother died suddenly of a heart attack. Mona's older brothers and sister were also confident of her ability to live on her own, but in time they too died. Fortunately, her nieces and nephews share that faith. Their support and encouragement, and that of a few special friends, have sustained her through many a difficult day.

Like the rest of the population, disabled people are now living longer. Aging brings the added challenges of arthritis, weakening muscles and frequent falls. Mona is concerned that even disabled people who were able to live fairly independently in their younger years are finding that they need more help. Much worse, this is occurring in an environment of severe cutbacks to government services for both disabled people and seniors. She believes that most groups that work with disabled people are ignoring the additional complications that old age brings them.

Very critical of what she describes as uncaring governments and indifferent non-governmental organizations, Mona sometimes finds it difficult to contemplate the future without becoming depressed. But she isn't one to let things happen around her, and her activism gives others a sense of hope. She has served on boards of directors that have initiated residential accommodation for young disabled adults, so that these people are not confined to hospitals or institutions. After reading about similar projects underway in Sweden, she advocated for apartments with support services for disabled adults. She wrote a column for the *Toronto Sun*, bringing to light issues and injustices faced by disabled people and celebrating advancements. And as a member of the board of trustees of the United Way of Greater Toronto, she learned more about the city's disadvantaged people and was encouraged by the board's sincere interest in the viewpoint of disabled people.

Mona finds many joys to appreciate in life, such as the pleasure of making new friends and the excitement of discovering authors who increase her knowledge and broaden her understanding. No matter what the future holds, she will always be thankful that she is able to remain independent, still living on her own.

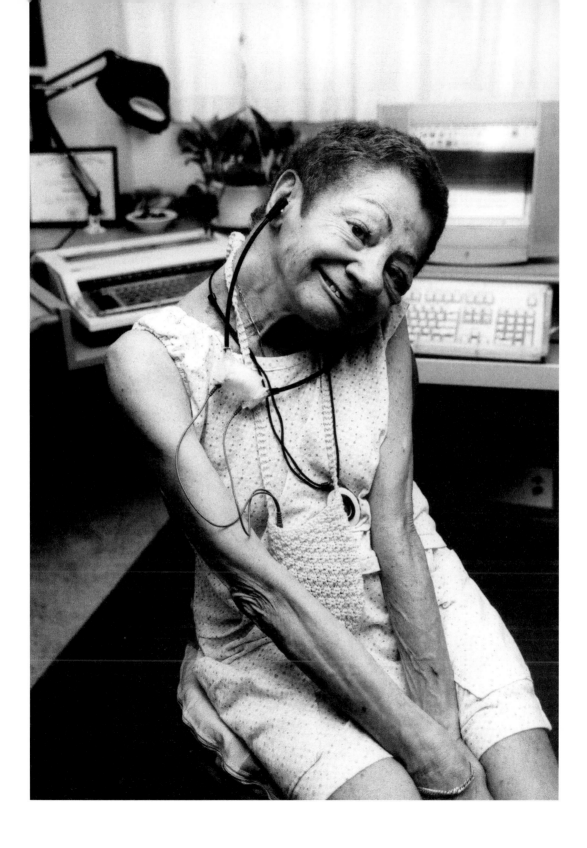

Emily Hearn

*Poet, children's writer, mother, grandmother, great-grandmother.
Born in 1925 in Markham, Ontario, Canada.*

Although Emily Hearn is seventy-eight, she has been quoted as saying, "I don't think I ever grew up."

Emily's father died when she was five years old. Her mother, a strong and loving woman, instilled confidence in her two children, giving them the freedom to think for themselves. Emily grew up believing she could do anything she set her mind to.

She is curious about everything new: writers, science, music, plays, and political attempts to alleviate social distress. She says that she "can't not make music and write." She finds that playing the piano, which she has done all her life, is like breathing, but writing makes her work; it is effort and experiment.

Emily loved scriptwriting for CBC radio and TV Ontario, but her writing now is mainly for picture books and poetry. She helped establish WIER (Writers in Electronic Residence), a virtual educational institution teaching writing to children, and she has been a mentor to young writers everywhere in Canada; they send her poems through the Internet. She is often a speaker in schools, and she revels in the honesty of kids' feedback, and in taking part in the whirlpool of cultures in Toronto.

Emily and her husband have eight children, all from previous marriages. Emily describes herself as a spiritual atheist. She doesn't believe in God, but she has a deep faith in the common good that exists in humanity. She still loves and trusts people. When her son died tragically a few years ago from brain cancer, her inner strength helped her through the tremendous loss.

So typical of Emily, she writes that "when [our cat] Fiona called from the couch where she was lying yesterday with her new kitten, 'Here we are, Dad, we're purring together,' I hoped I could keep a little of the freshness, just not grow up too much!"

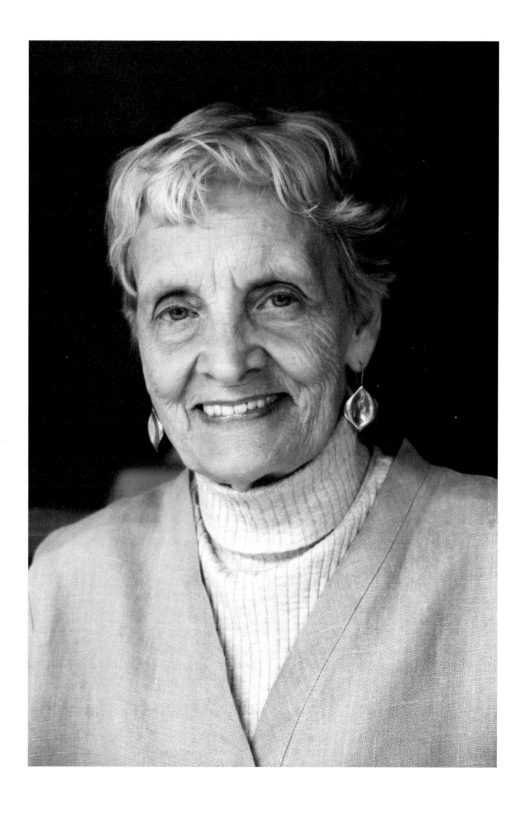

Swami Pramathananda

Spiritual leader, writer, lecturer. Born in 1920 in Calcutta, India.

Swami Pramathananda joined the Ramakrishna Order of Monks in 1950. He served in many branch centers of the order in India and the United States before being appointed Swami-in-charge of the Vedanta Society of Toronto in 1989. As a chaplain of the University of Toronto, he conducts monthly classes on the Vedanta philosophy, a system of philosophy based on the four ancient sacred Hindu books known as the Vedas.

The swami teaches that a spiritual life should be balanced, and should be built through meditation, devotion, knowledge, service and action. He feels that people should not always be thinking of themselves but should be concerned for others.

Still very involved in his eighties, the swami meditates three times a day, does breathing exercises, and eats a well-balanced diet in moderation. He lives his life with a positive attitude.

Adherents to the Vedanta philosophy believe that love and compassion are necessities, not luxuries; without love and compassion, humanity cannot survive. They believe not only in universal tolerance but also in the acceptance of all religions as being true; thus love for your own religion does not have to mean hatred of other religions. Further, the swami explains, they believe that sectarianism, bigotry and bigotry's horrible descendant, fanaticism, have long possessed this beautiful earth. These bitter feelings have filled the earth with violence, drenched it often with human blood, destroyed civilizations and sent whole nations into despair. Had it not been for these horrible demons, he says, human society would be far more advanced than it is now.

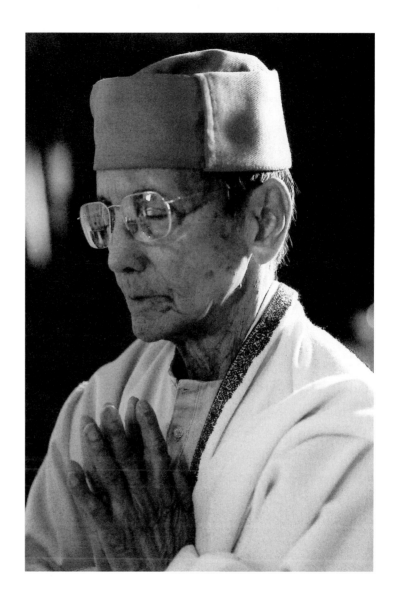

Anne Millyard

Writer, publisher, artist, mother, grandmother. Born in 1929 in Frankfurt, Germany.

Anne Millyard was born in Frankfurt, Germany in 1929, and raised and educated in Berlin. After a stint at an art college she joined a charitable organization providing legal services for unmarried mothers. She followed that with two years in the foreign office of Konrad Adenauer's government in Bonn, and put in another two years in the motion picture industry. In Munich she met John Millyard, who was working his way around Europe. They married and eventually returned to his native Toronto.

Their children, Kai and Karen, grew up in the age of "free schools," and were educated in one of these learning communities founded by those who sought a new approach and greater involvement in the schooling of their children.

When the free school closed, Anne felt that she had gained important insights into the needs of young children. She came away from the experience determined to create a forum for the voice of children in Canada, and with Rick Wilks founded a not-for-profit publishing house called Books By Kids in 1975. Their first title became a bestseller and the second won a design award, so naturally Anne and Rick assumed publishing was a cinch and embarked on a "proper" publishing program with adult authors as well as children. The new venture was called Annick Press, and became a highly successful company, voted "Publisher of the Year" in 1984.

After twenty-five years, Anne retired at the age of seventy. She wanted time to reflect, read materials of her choice, and, above all, write. Now nearing seventy-five, she was approached recently by a former colleague to help create a new small children's press. Anne agreed to come back, and feels very privileged to once more be part of a team that hopes to help children, all children, walk in the world.

Anne also feels fortunate to be healthy, and enjoys being a grandmother. She is somewhat surprised at her energy and renewed interest in learning, and has yet to experience the "trend towards more conservative thinking" frequently forecast for one's riper years. Quite to the contrary, Anne finds that she is rediscovering her humanism. She believes that societies around the globe need to take responsibility for the havoc human beings have created on the earth, and that we can ill afford to lose the contribution of older citizens. She has faith in the capacity of human beings to work toward greater harmony on earth, and is striving to do her part.

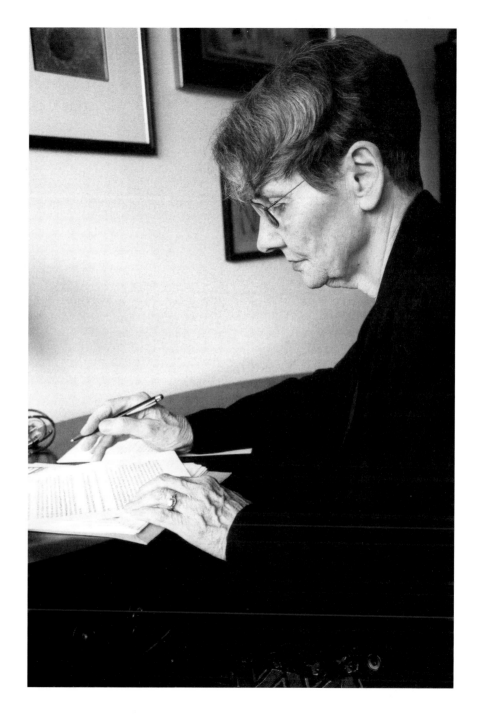

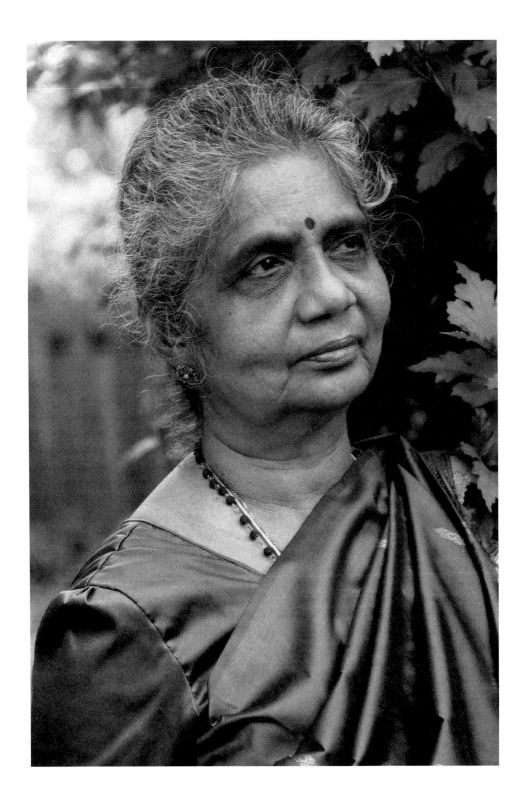

Lallitha Brodie

Counselor, broadcaster, poet, volunteer, wife, mother, grandmother.
Born in 1934 in Jaffna, Sri Lanka.

Although Lallitha Brodie respected her mother, she felt closer to her father, and was most influenced by him. She describes him as a very moral man, and believes his values became her values. He also instilled in her his great appreciation for music; she took violin lessons and learned to sing. She sees her love of music as a gift from him.

After moving to Canada with her husband and their two children in 1992, Lallitha struggled to find her identity as an independent woman within a traditional marriage, while trying to adapt to a totally new life in a very different country. One of the ways she adapted was by embracing spirituality. She became less materialistic and could better deal with the tribulations imposed upon her.

Lallitha believes that difficulties arise in life to make us turn toward a higher power. She claims that the secret of aging graciously is to learn to accept our allotted life, enjoy our relationships, and work our way toward self-actualization through the balanced growth of mind, body and spirit – though she feels that people are essentially their inner spirits, more than their bodies or their minds. She expresses herself in poetry that she shares with others, and sings with a devotional choral group.

Lallitha believes she is a source of inspiration to others, as she has set an example for people in the Tamil community who are experiencing problems in their new country. Since 1993, through a radio program and a television program, Lallitha has interviewed Tamil people and other Canadians, discussing issues of importance to both her community and the country as a whole. She also introduces outstanding individuals who inspire others and demonstrate what it is possible to achieve. She is pleased that, as a senior, she has time to share her knowledge and wisdom with others, and hopes to leave the world a better place when she is gone.

Dr. Henry Morgentaler

Physician, social activist, humanitarian, husband, father, grandfather.
Born in 1923 in Lodz, Poland.

Henry Morgentaler is a physician who has put his life on the line as an advocate for justice and women's reproductive rights. His parents, who were socialists and fighters for social justice, taught him the importance of being useful and trying to make a difference in the world. They had a great influence on his values, and he has always tried to lead a similarly courageous life. Both parents were killed in the Holocaust, and Henry himself survived the Auschwitz and Dachau concentration camps.

Henry's recovery from an illness after liberation inspired him to pursue a career as a doctor. He obtained a scholarship to attend medical school in Germany, and then he continued his studies in Brussels. Henry immigrated to Canada in 1950 and became a general practitioner. In the 1950s he adopted a humanist perspective. All religions became poisonous to him, and he publicly argued for the introduction of secular schools in Quebec.

In the 1970s Henry was charged numerous times for operating a then-illegal abortion clinic in Montreal, and became a public face for the issue through his efforts to provide women with access to safe medical abortions. His court case, heard in the Supreme Court of Canada, resulted in the ruling that restrictions on abortions were unconstitutional. Since then Henry has pushed authorities in various provinces to make women's access to abortions easier through the operation of freestanding clinics.

Henry's life quest has been to work against the kind of evil that he and millions of others suffered in the Holocaust. He believes that Stalin and Hitler were both brutalized as children. He also believes that people who are loved as children do not build concentration camps as adults. Children need to be raised in a family where they will be nurtured, treasured and respected, so that they can develop into compassionate, responsible and loving adults. Henry does whatever he can to create a society where all children are wanted and cherished. He believes that allowing women choice in whether or not to have an abortion will decrease the abuse of unwanted children and therefore help to diminish the cycle of evil.

Henry still works long hours in his Toronto clinic, even as he approaches eighty. He relieves the stress by walking regularly to keep active and by pursuing his hobbies of chess, Ping-Pong and singing.

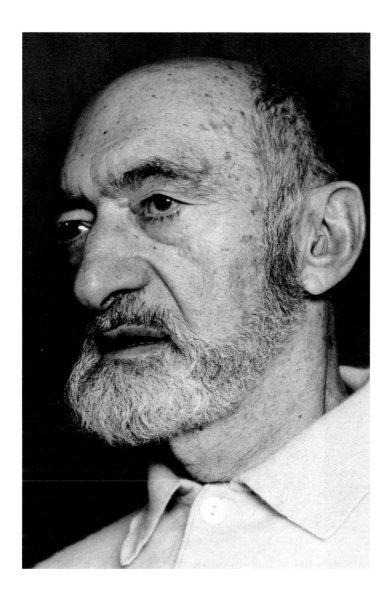

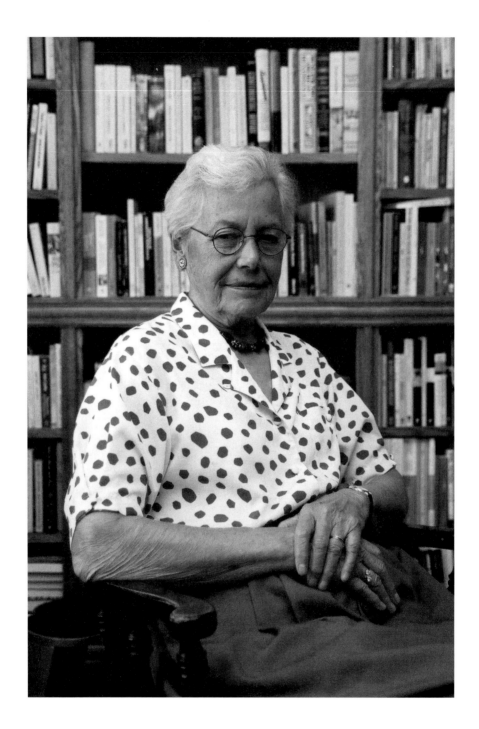

Katherine Morrison

Writer, scholar of North American literary history, wife, mother, grandmother.
Born in 1925 in Detroit, Michigan, U.S.A.

Katherine Morrison was a dreamy, somewhat timid only child, a late bloomer in a family that would today be called dysfunctional. A lack of hand/eye coordination made her poor at any kind of team sports, and what was probably dyslexia — unknown at the time — made her a mediocre student. Once she conquered reading, however, books and her imagination became her great consolation.

As an undergraduate, Katherine became infected with wanderlust. Her desire not to return home after graduation led to a job as a stewardess with United Airlines from 1947 to 1949. The work was mundane, but she and a friend managed trips to Mexico and Europe in a day when single young women were not supposed to trot around foreign countries unchaperoned. In 1949 she married a Canadian.

Katherine worked for the Girl Scouts in Chicago and for the Red Cross in Nashville, Tennessee, where her husband taught at Vanderbilt University. He was anxious to return to Canada, so the couple and their three children landed in a suburb of Toronto. Katherine broadened her world with piano lessons, the creation of a cooperative nursery school, and Girl Guides. Once the children were in school, she decided to qualify for high school teaching. She completed some necessary courses at the University of Toronto just before the family moved to Montreal. By now she was sufficiently bitten by the scholarly bug to endure the embarrassment of being the only "oldster" in a class full of young people, so she completed a master's degree. After the family moved back to Toronto she launched into a PhD, which she completed at the age of fifty-four.

At the time, there were almost no full-time teaching jobs available. Katherine published some scholarly articles and taught literature at U of T's School of Continuing Studies for several years, until a painful and debilitating illness made work impossible. It was over a decade before major spinal surgery restored her health and energy. At the age of sixty-six it was too late for her to return to teaching, but she now had an idea for a book. After a decade of writing and revising, *Canadians Are Not Americans: Myths and Literary Traditions* was published in 2003.

Just shy of her eighties, Katherine is touring with her book, swimming several times a week and commuting regularly to an island home where she copes without electricity.

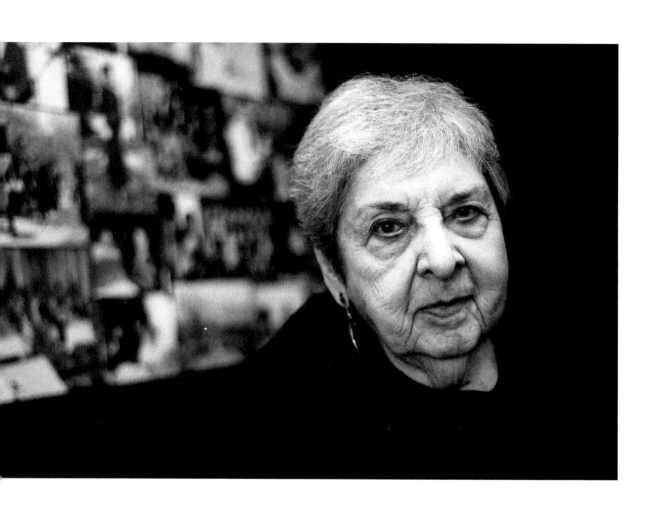

Florence Rosberg

Teacher, mother, grandmother, great-grandmother.
Born in 1913 in New York, New York, U.S.A.

Florence Rosberg, a woman with impaired hearing, impaired mobility and consequently a restricted social life, received a computer for her eighty-fifth birthday as a gift from her family. The computer enabled her to communicate by e-mail with friends and distant cousins she hadn't been in touch with for years. She didn't just re-connect with them in a personal way; by creating her own newsletter, she introduced all her connections to each other.

In no time, Florence was sending and receiving hundreds of messages, on everything from politics to potato pancake recipes. She wrote about current events, theater and of course her lifelong passion, reading and literature. Many of her correspondents sent back wonderful stories and jokes of their own. Before long, Florence was acting as a clearinghouse, circulating volumes of useful or useless information among hundreds of people of all ages who got to know each other through those newsletters.

Having been a high school English teacher for many years, Florence uses the computer to locate and contact hundreds of her former students, many of who are themselves grandparents. They all enjoy the opportunity to exchange news with her and with each other. As a result, many of her students, who now reside all over the United States and Canada, have come to visit her in Toronto. "It's what keeps me out of the obituary column," she says with a laugh. "I love the chance it has given me to renew the past, and to enjoy the present moment. You have to admit it beats talking about what ails you, or listening to what ails the others. The downside, of course, is that you do get to hear a lot of jokes you've heard before, some of which weren't funny to start with."

Florence's e-mailing, weekly meetings of her literary club, an occasional game of Scrabble on the Internet, and the monthly Sunday afternoon literary seminars she has conducted since 1975 have kept her happily involved with her friends and family. "You never know who it is you're standing next to," says Florence, "so I always assume that that person is at least as worth knowing as I am, and that, like me, they also must have an interesting story to tell. If I get to know them, I will recognize that we may even be related or connected in some mysterious way."

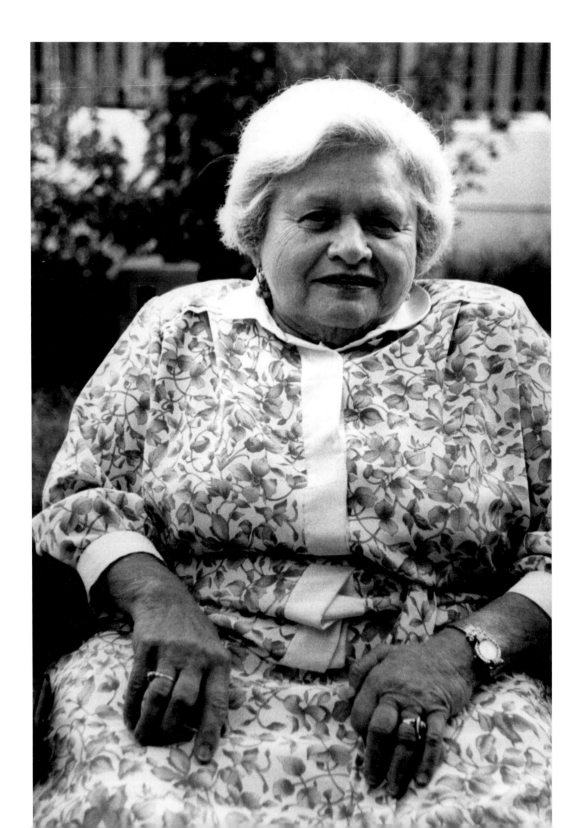

Etta Ginsberg McEwan

Past Director of Social Work – Baycrest Centre for Geriatric Care in Toronto, writer, activist, speaker, volunteer. Born in 1926 in Brooklyn, New York, U.S.A.

Etta McEwan contracted polio (infantile paralysis) at the age of five, and the disease in many ways determined her personality. Family who knew her as a child said she was always independent and stubborn, and "spoke her piece." These traits became more pronounced during her years of institutionalization, and in her encounters with arrogant health-care professionals who thought they knew what was in her best interests.

Before the polio, Etta had always thought she would grow up to be a ballet dancer and a baseball player, but it was not to be. Instead, Etta decided to become a social worker, because she knew that advocacy would have to be her life's work; she had seen too much suffering and cruelty inflicted on others who could not defend themselves. Battling those who thought she should settle for secretarial work was no easy task. People with any kind of disability were usually told – and sometimes forced – to settle for second best. Etta knew she would not accept that.

Etta became a skilled social worker, and made her way up to directorships. She also became a mentor to many able-bodied professionals, and set high standards for their work with individuals and families in trouble. As for people with disabilities, she let them know that most anything is possible for those who work hard and don't give up.

After retiring from paid work, Etta became coordinator of the Toronto Jewish Healing Project, a program that offers services from a Jewish perspective for those seeking spiritual, physical and emotional healing. She also serves on the Research Ethics Committee of the Social Sciences and Humanities Committee at the University of Toronto.

Etta's advocacy, leadership and ability to say what others dare not put into words brought her to the attention of the CBC Television program "Moving On," which deals with issues concerning the disabled. She appears as a commentator about six times a year.

While Etta moves about her apartment with crutches and leg braces, she uses a motorized wheelchair to get around. Of course, there are days when she wants to "chuck it all," but then she becomes infuriated by some incident of injustice and has to speak up. "Being enraged is probably good medication to help you slow down aging and remain in the mainstream," she says.

Raymond Gould

Court worker, addiction counselor, Native spiritual leader, liaison worker, father, grandfather. Born in 1933 in Saint John, New Brunswick, Canada.

Raymond Gould is part Maliseet aboriginal and part Acadian. While he was growing up he was constantly derided because of his heritage. He believed he would never amount to anything, and saw himself as a failure.

From ages sixteen to thirty-nine, Raymond drank and used drugs to make himself feel confident. He ended up in jail, and began to ask himself, "Is this the way I want to spend my life?" He decided to change his ways when he joined an Alcoholics Anonymous group that he discovered while in jail. He found the group inspirational, and he liked its motto, "One day at a time." He started to sing at AA socials, and performing there helped Raymond increase his self-esteem.

Through a professor of Native Studies at Trent University, Raymond became aware of Native spirituality for the first time, and this discovery helped change his life. He realized that he had difficulty with structured Christianity, but he could relate to Native spirituality. He describes this discovery as a "spark that came alive…there had always been a spark there, but it was not lit."

With his new understanding, Raymond began to counsel others while continuing his own recovery. Helping them change their lives, and find meaning and purpose within the community, was a boost to his own healing, and gave his life direction and richness. He believes that he can influence young people before they turn to drugs and alcohol, because he can teach them from his own life experience. He continues to promote tolerance, patience and respect, and has extended his teachings to street people. His family is also an important part of his life.

Raymond feels that Native elders should have the right to perform marriages and birth and death ceremonies in their society. This right would empower them with the stamp of authority, and their teachings on other matters would be more likely to be accepted. This in turn would give them more influence on Native culture, and on Canadian society as a whole.

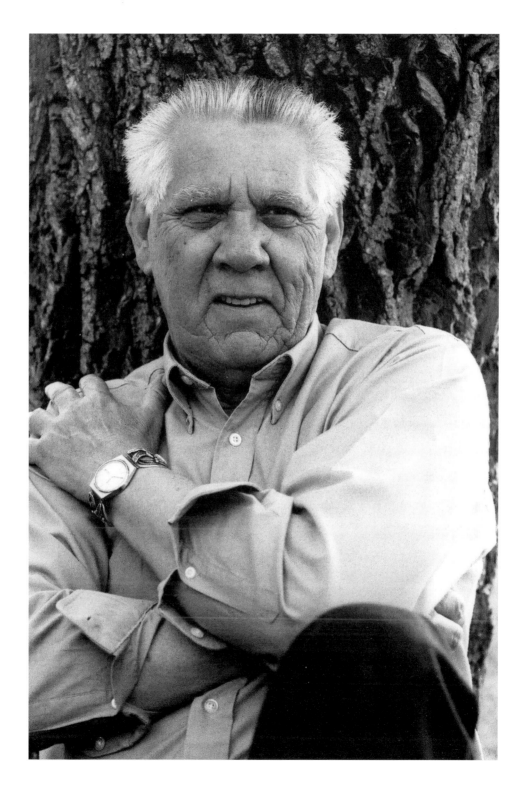

Sara Pachter

Group travel coordinator and tour leader, community activist, mother, grandmother.
Born in 1915 in Edmonton, Alberta, Canada.

Sara Pachter was born into a loving home and came to respect both her parents. Her father was an intelligent and adventurous man and her mother had a strong business sense. Both of these influences were an inspiration for Sara when she started out in the travel business in 1959.

For much of her adult life Sara traveled the world as a professional tour guide and she continues to escort travel groups worldwide. She has organized and led tours to China, Russia and much of Europe. One of her most interesting experiences was leading a group of doctors to Russia to provide medical care for those in need. She takes three or four groups abroad each year, and every trip generates new stories and memories.

Regular exercise helps build up her endurance for the rigors of her work. She has never worried about getting older, and remains interested in the world around her. She has no intention of retiring as long as her health and stamina hold out. She admits, though, that she is not as active as she would like to be. She especially feels her age mentally. "I am a lot slower in thinking about dates, and a lot slower about things related to my work, but I know that if I concentrated a little harder, I would give the impression that I know what I am talking about. It is short-term memory that is the problem…we reminisce a lot, and can remember things that happened ages ago." However, such problems are just momentary impediments to her work, for which she has lost none of her enthusiasm.

Sara married in her early twenties, and she and her husband were happy together for almost sixty years, raising two children. A highlight was when her son Charles, the well-known artist, became a Member of the Order of Canada. She also takes great delight in her grandchildren, and anticipates the same closeness with great-grandchildren. It makes her day when people stop her on the street to tell her that they traveled on her arrangements, or even with her, to exotic destinations. She looks forward to meeting new people on future trips, and is busy planning her next group tour, this time to Israel.

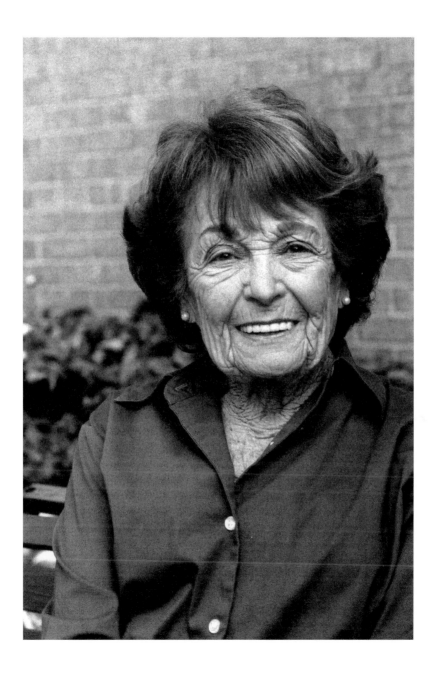

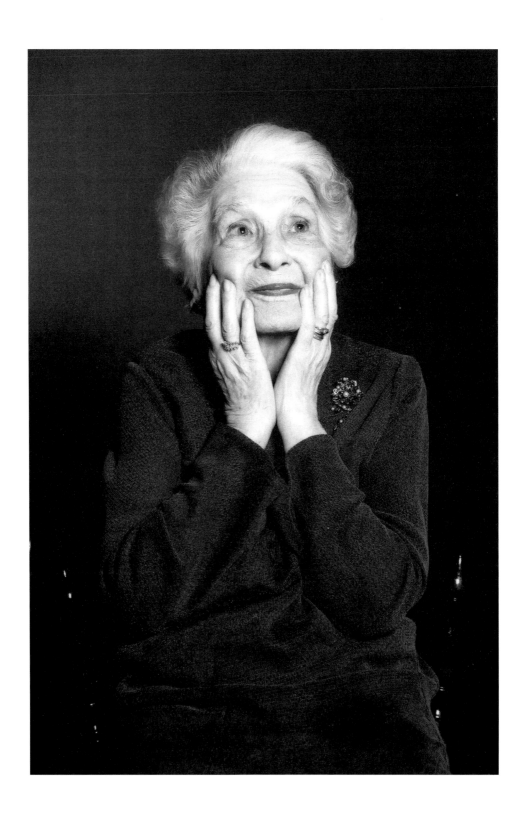

Eleanor Beecroft Stewart

Actress, mother, grandmother, great-grandmother. Born in 1906 in London, Ontario, Canada.

Eleanor Stewart was an only child. Her father left the family when she was young but came back into her life when she was sixteen. Her mother was very Victorian in her outlook and didn't really understand her, but Eleanor had an aunt who became a good friend. Eleanor was also close to her father, who gave her inner strength that made her independent and determined through the years. She left home at the age of twenty, desiring to be on her own and away from her mother.

Eleanor graduated from the University of Toronto in 1928, specializing in languages, but she decided not to become a teacher; acting was to be her life. Her career was facilitated by her "automatic" memory. She had started acting in amateur productions at fourteen, and became a professional actress in 1929. She was married in 1931 and had five children who have remained devoted to her.

Eleanor separated at age forty – her husband was very controlling – and started life again with "ninety cents" in her pocket. She had to become self-supporting, but she wanted to be herself and to act. Something inside her told her she could do anything she wanted to, if she just set her mind to it. She succeeded, playing in many theater companies across

Canada, as well as in early Canadian television programs.

Eleanor lives at the Performing Arts Lodge, a high-rise residence for seniors involved in the arts, in downtown Toronto. She loves this community of retired people, and finds them all helpful, and understanding of each other's artistic background and temperament. The residents continue performing in the communal gathering room, which includes a stage with functioning accoutrements.

Eleanor accepts the fact that loss and changes in the body are a normal part of aging – she used to be five foot two inches, and now she is just four foot nine inches tall. But she sees herself as an eternal optimist, and a survivor despite numerous surgeries. She feels it is up to each of us what we make of our lives. Her advice to people of all ages, especially seniors, is not to complain about their lives but to find the best in them, and to celebrate and look forward. We all have problems; you can choose to focus on either the darkness or the light.

Dr. Bernard Ludwig

Obstetrician, gynecologist, lecturer, teacher, husband, father, grandfather.
Born in 1922 in Toronto, Ontario, Canada.

Bernard Ludwig's parents came to Canada from Romania as young children and met later in Toronto. He was raised in a quiet, relaxed home where the parents tried to ensure that their children got whatever they needed. He learned from them to have compassion for others, as they were very aware of underprivileged people in the community, and his mother did her best to help new immigrants when they arrived in Toronto. He feels that his compassion for his patients came directly from the teachings of his parents.

Bernard's mother suffered from acromegaly, a rare glandular disease, and this was the beginning of his interest in medicine. He graduated from medical school at the uncommonly young age of twenty-two.

Bernard has had the joy of delivering about twenty thousand babies, and is one of the best-known obstetricians in Toronto. He has been described as "a legend in his time," because he is extremely dedicated and devoted to his patients' welfare. He believes that, to practice medicine well, a health-care professional must be in touch with the entire person, and see her or him as a complex, multifaceted, unique individual.

Over eighty, Bernard still practices family medicine six days a week; on the seventh day, he phones his patients about the results of their tests. He exercises daily, eats carefully and reads continually about current medical trends and developments. He believes that his knowledge needs to be as up-to-date as that of younger doctors, despite his age. With his lifetime of experience he has a great understanding of many areas of medicine, and is widely acclaimed as a skillful diagnostician.

Bernard believes that aging begins at conception and continues throughout life. The earlier we become aware of our aging process, the better we will fare in our later years. Discipline is a key factor: overeating, lack of exercise, smoking and excess alcohol all hinder our ability to age well. Bernard says that exercising on a regular basis, and eating correctly and monitoring our intake, can slow down the aging process. Although genetics play an important part in the process, he feels that habits of self-discipline can overshadow heredity.

Bernard feels that seniors in today's society should forget about their own aging, and keep up with the world's progress and every aspect of life around them. Live life in the present, he says, not the past.

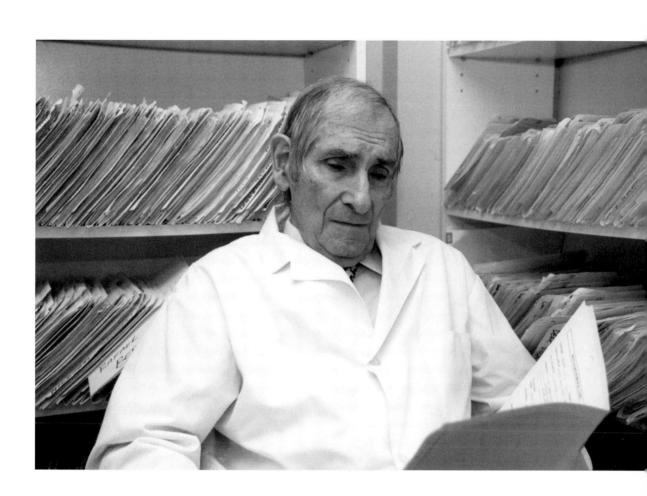

Patricia Moffat

Social worker, singer, activist, mother, stepmother. Born in 1935 in Carshalton, England.

Patricia Moffat's family has been involved in the struggle for peace and social justice for several generations. Electoral politics, the social gospel, Fabian socialism, women's suffrage and the settlement movement all saw action from her foremothers and forefathers.

Patricia grew up south of London, in a close-knit community between the wartime airfields of Croydon and Biggin Hill. Her mother, a singer, hosted gatherings where the family shared stories and history, along with their tradition of choral music.

Patricia was taught and influenced by Quakers (the Society of Friends) when she worked in child welfare in South London, in immigrant communities and in new housing estates built for families made homeless by the air raids.

Arriving in Toronto in 1962 to do social work for the Children's Aid Society, Patricia soon connected as a chorister with the famous composer Dr. Healey Willan, organist and choirmaster at the Church of St. Mary Magdalene. She has remained involved with the church's music and liturgy ever since, and treasures her musical friends of all ages.

In the politically active mid-sixties, Patricia spent two years at Case Western Reserve University in Cleveland, Ohio, to complete her master's degree in social work. Her return to Toronto connected her with Quakers again, over the issue of resettling Americans who opposed the Vietnam War. For several years she was the editor of *Quaker Concern*, a tabloid published by the Canadian Friends Service Committee.

Since 1981 Patricia has worked with the elderly in health care, especially in developing group work programs for patients and caregivers, in which a leader facilitates group discussions of issues. She uses e-mail to exchange news and plans with family and friends. Her daughter and five stepchildren challenge and delight her, and keep her up to date.

Patricia believes in the power of people in small groups to effect personal and social change. As a member and past chair of the Toronto Region Groupworkers Network, she teaches and writes about group work models and program development. In the Older Women's Network, she campaigns for better access to housing and health care. She expects to be involved in a lot of new initiatives in the coming years, as older women move to the forefront of social change involving the local and global concerns that affect us all.

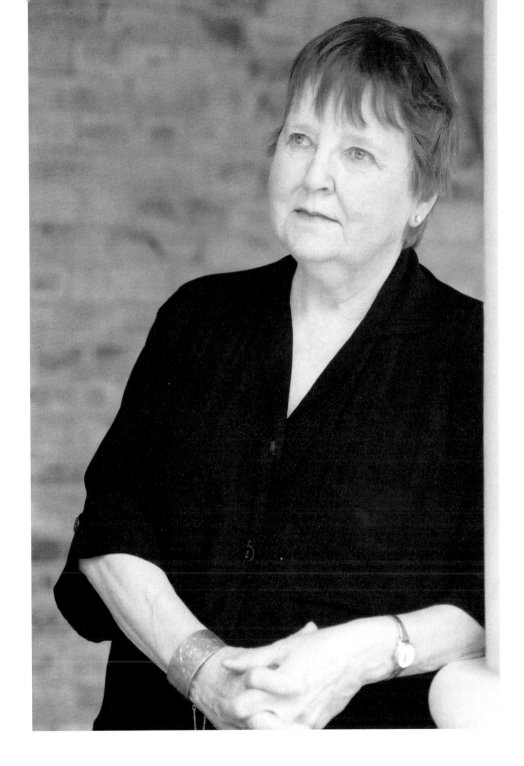

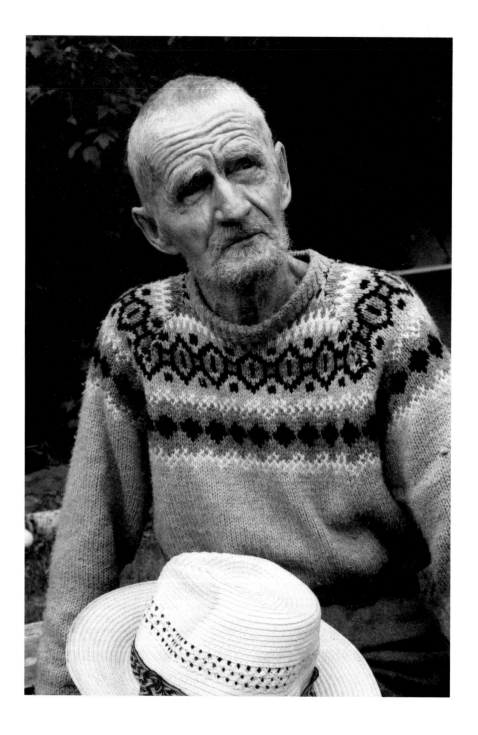

Fred William Dunn

Carpenter, peace activist, poet. Born in 1923 in Toronto, Ontario, Canada.

Fred Dunn has been alone most of his life. He was born out of "wedlock," to a young woman from a working-class family and the son of a wealthy livestock merchant. His father refused to marry his mother and risk his reputation. When Fred was two, his mother was institutionalized for tuberculosis. She died four years later, in a sanitarium, leaving Fred quite alone. He lived in foster homes but the relationships did not last long. In earlier years he felt inferior because of the way he was raised, but his self-esteem has improved due to a sense of independence and self-awareness that has developed over time.

Fred has made his home in the Rosedale Ravine, off the Bayview extension in Toronto, for the last fourteen years, in a dwelling he has named Camp Goodwill. He made this choice because he did not want to take money from the government. Although Old Age Pension is available to Canadians at age sixty-five, Fred did not take any money until he turned seventy-nine, at which time he felt that he could use a little help. He eats at various community outreach facilities, and receives medical treatment from a street-based health unit. Asked about religion, he says he believes "God is a feeling of oneness with humanity and with the earth."

Fred manages to maintain good health despite adverse living conditions. Surviving a brutal Canadian winter while living outside isn't easy, but he believes that the body adapts to colder temperatures when necessary. The house he grew up in was not well insulated, and this has helped him adjust to the inclement weather he is so often exposed to. He feels the body fares better in a cooler environment.

Terry Fox is a role model to Fred; he jogs daily and carries weights that he built from scrap wood. He also reads the newspaper every day, to keep his mind active and alert. He attends peace rallies and makes his opinions on local and international affairs known to politicians whenever he gets the chance. In a binder in his dwelling he keeps numerous poems he has written, and he is happy to recite them to visitors. Fred feels he's aging in his body but not in his mind, and advises others to keep physically fit and to be as independent as possible.

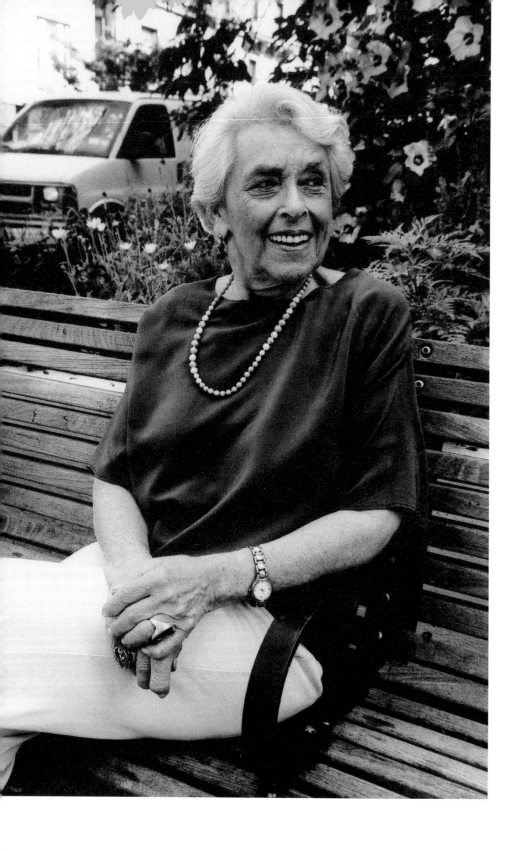

Fran Sosnoff

Retired Associate Professor Emerita, Wurzweiler School of Social Work at Yeshiva University, New York City, social worker, activist, mother and grandmother. Born in 1923 and raised in New York, New York, U.S.A.

Fran Sosnoff's parents arrived alone and separately from Poland as teenagers; her mother worked in a needle-trade sweatshop, her father as a clerk in a grocery store. When the young couple found that they could not have children, they adopted Fran as an infant.

Fran's parents were very loving and dedicated. As democratic socialists they were active in union-building and other social-political causes. They were also committed to Judaism, not religiously but culturally. Their beliefs took root in Fran as she accepted their values. She learned to speak and read Yiddish, and studied Jewish history, literature, songs, dance and art. "I was also exposed to my parents' political thinking and proudly believed in a more equitable, humane world for all people," she says.

Fran became a Yiddish typist and stenographer working at various Jewish cultural institutions. In 1946 she resolved to work on the American Joint Distribution Committee, an overseas Jewish relief agency trying to deal with the aftermath of World War II and the Holocaust. She went to Poland to work with repatriated survivors from the concentration camps as well as the Soviet Union. Her experiences compelled her to seek a master's degree in social work. As a social worker in a number of casework agencies, she dealt with many ethnicities and was a supervisor to students of social work.

In 1977 Fran was invited to join the faculty of New York's Wurzweiler School of Social Work, where she remained until 2002. She taught courses in human behavior and social environment and in group work. She found it exciting to engage bright young minds struggling with social concerns and investigating social work as a profession, and her students found her outgoing, passionate and demanding. She hopes she helped them find the profession to be dynamic and challenging.

Fran is widowed and has one daughter, a talented musician and social worker, and a grandson. Although she misses many old friends, she treasures those who are left, and tries to build new friendships – often with younger women. Her love of learning and discussing social issues endures, and she has fun being her age. Her enjoyment probably comes from her attitude of self-acceptance, and from the fact that she still takes full advantage of New York's cultural cornucopia: music, dance, drama and other cultural pursuits.

Sister Constance Murphy

Sister at St. John's Convent in Toronto, writer, teacher. Born in 1904 in Baltimore, Maryland, U.S.A.

Sister Constance Murphy had been exposed to nuns throughout her childhood. Gradually, she came to feel that she had a calling to dedicate her life to God's service, and that she had to answer it. Her father was supportive of her choice and helped her find her own direction. Her mother did not want her to become a nun, however, so Constance left her home in Baltimore and moved to Toronto to pursue her passion.

Constance went to Europe and visited several convents and churches, and she continued to feel that giving her life to the Church was the right decision. She pursued higher education, earning her master's degree in education, and taught elementary school as her chosen profession.

Reflecting on her life, Sister Constance says, "I've enjoyed life! God has given me a blessed life. I have no regrets, and wouldn't change anything if I had to do it over. I enjoyed going to university and I feel I was blessed in the opportunity to continue learning throughout my life and making use of my education. My life has been useful and fulfilling." She has written a book about her experiences called *Other Little Ships*.

Sister Constance has found that being a senior in today's society has also been a positive experience for her. She moves easily into any age group, communicating well with her elderly friends but also with younger people. Her days are spent reading, meeting with children at the convent and contacting friends, and she always allows for time to sit back and contemplate.

When asked what advice she can offer others, she says that "to get through life and do it well, one should have a purpose, a profession, be connected to a community, participate, do for others, have close friends that you can trust, have a firm belief in a loving and forgiving God, be grateful and compassionate, find pleasure in the little things, learn not to complain – and just GET ON WITH IT!"

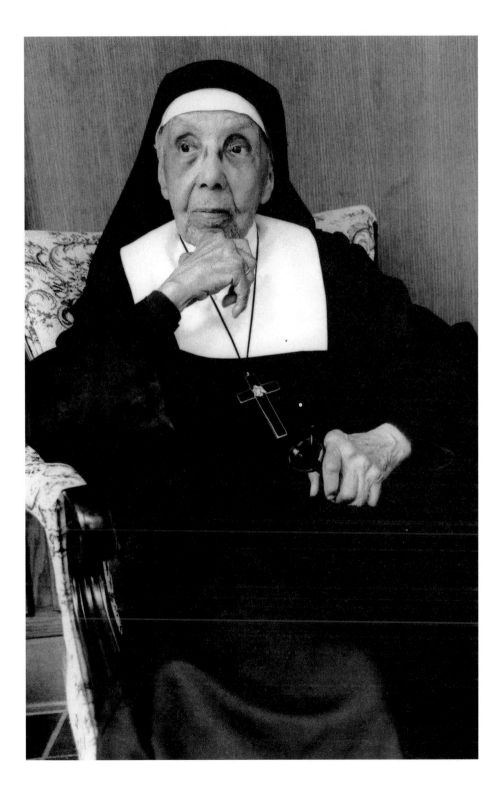

Rabbi W. Gunther Plaut

Senior Scholar of Holy Blossom Temple, author, lecturer, humanitarian, Companion of the Order of Canada, adjunct professor at York University, World War II veteran, husband, father, grandfather, great-grandfather. Born in 1912 in Muenster, Germany.

Rabbi Gunther Plaut grew up in Germany. He graduated from law school but left the country due to the political situation. Once he reached the United States he became a rabbi, and joined the U.S. Army as a chaplain. During his tenure he was part of the liberating force opening up a death camp. After the war, he left the army and became a rabbi for congregations in Chicago and St. Paul, Minnesota before settling in Toronto.

He became a rabbi and then a rabbi emeritus at Holy Blossom Temple, and is past president of the Canadian Jewish Congress. Since coming to Canada he has also made an enormous contribution in the area of human rights. He lectured on refugee studies at York University, and for seven years was Vice Chair of the Ontario Human Rights Commission. In 1984 he was appointed by the Canadian government to revise Canada's refugee legislation.

To Rabbi Plaut, aging is a privilege, and something one has to experience for oneself. It is not visible to the eye, for it is a new state of one's spirit, which involves changed priorities, reordered values and, one hopes, a pervasive sense of gratitude. He himself has experienced growing old as a time of serenity, ease of mind and growth.

Rabbi Plaut has had a relationship of total trust with his wife, Elizabeth, which became the frame of their lives together. He feels that the capacity to love remains, and still needs to be nourished and used, as one ages.

The rabbi has learned this capacity to love even more since the year 2000, as his wife has been felled by a series of strokes; she is now entirely paralyzed and unable to communicate. Despite this, he greets each new day gratefully and whispers the traditional Jewish morning prayer, which features the words *modeh ani*, "I give thanks!" – thanks for being alive and still attuned to the world, ready to face whatever comes, within the limits of his power.

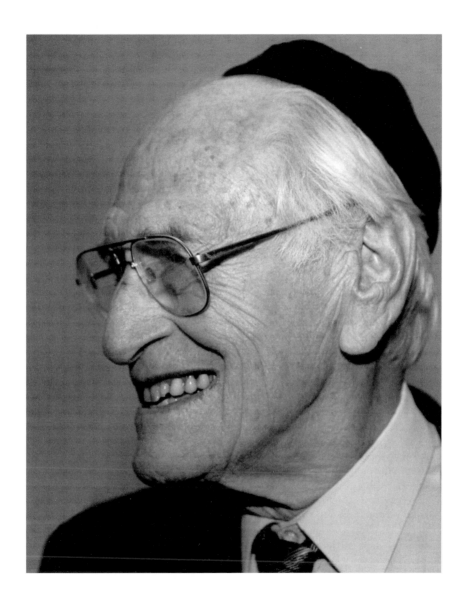

Ann Seaton

Former principal of the School of International Cooking, columnist, mother, grandmother.
Born in 1917 in Detroit, Michigan, U.S.A.

"I'm still excited with living! Each day is a gift to treasure and use. I have a great desire to live, not just to exist. I'm not ready to let go yet. I'm curious about what will happen next — to my family, to me and to the world."

Ann Seaton suffers from congenital dislocation of both hips and from the effects of a stroke, but she has a motorized scooter for transportation, which offers her the freedom to lead an interesting and varied life. Her positive attitude comes from the teachings of her parents, who gave her the freedom to think for herself when she was growing up.

Even though Ann's mobility has been affected since birth, this condition has hardly slowed her down. In the 1950s and 60s she was the principal of a cooking school in Toronto (since closed), and wrote a column on cooking and nutrition for the *Toronto Star*. She married and had three sons, and is now a proud grandmother and great-grandmother. She has always volunteered with women's organizations, and she belonged to a group that inspects nursing homes and retirement homes.

Friends of Ann have said to her that they never want to live in a nursing home, because they see this as the next step to death. Ann does not share this opinion. After having a stroke in 1988, she herself decided to move to a nursing home, where she could get the care she needed. She is now living a rich and full life in this supported environment. She takes wheelchair-accessible public transit to go to the symphony and the opera on a regular basis. She also participates in the numerous activities planned for the residents of the nursing home.

Ann feels that she is living some of the best and most rewarding years of her life, as she is free to explore life with no worries about cooking, cleaning and household responsibilities. She is living according to her own choices. She has made a decision to enjoy each day to its fullest, as she doesn't know what tomorrow will bring.

Ann is an agnostic; she believes in the power of the individual, and in his or her ability to reason. She is not afraid of her impending mortality, as she has had several scares in the past. She believes that by facing her mortality she feels freer and more alive in all her encounters.

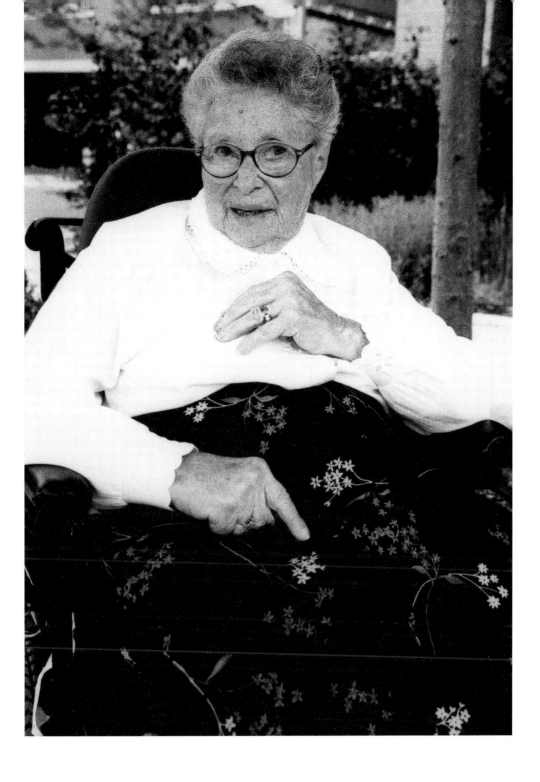

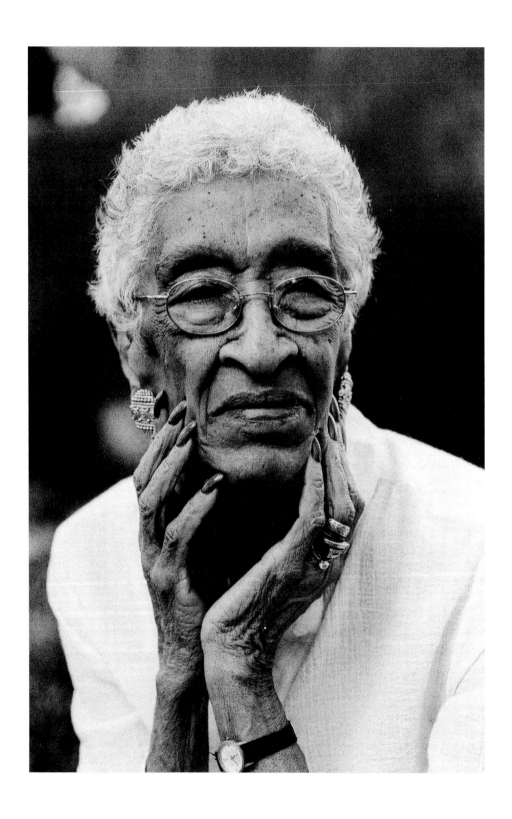

Evelyn Cunningham

Journalist, government worker, community activist, recipient of the George Polk Award for lifetime achievement in journalism. Born in 1916 in Elizabeth City, North Carolina, U.S.A.

Evelyn Cunningham's mother was a highly creative dressmaker and designer who was able to get good jobs because she could "pass" for white. Her father, a piano player, had a great influence in teaching her that she could do anything, and that she should not accept being pigeonholed because of her gender or her race. Evelyn feels he was a feminist long before the concept became common. Growing up in a close-knit Harlem community also gave her confidence.

Evelyn's parents read numerous newspapers daily, and discussed the news. She was fascinated by the powerful people who wrote such stimulating words, and she resolved to become a writer, despite the obstacles of gender and race. After getting a degree in sociology from Long Island University — where she became captain of her fencing team just because no Black woman had ever been on the team before — she moved around the country in various journalist positions. She covered hard news such as the civil rights movement in the South and other political reportage — never the fashion shows or weddings expected from a woman reporter at the time.

As a journalist, Evelyn developed strong political opinions that ran counter to those of her community. She became a Republican in a strongly Democratic area, and was special assistant to Governor Rockefeller for seven years. Her experience with the inner workings of government remains useful in her work as a community activist. She has a reputation for fighting through red tape and getting things done.

Despite the demands of her career, family has always been a priority for Evelyn. Her brother, Clyde, a New York police officer, had kidney problems in middle age. Although kidney transplant surgery was still experimental, Evelyn offered to donate one of her kidneys. She was already on the operating table when her brother died. She overcame this painful loss through her spirituality.

In addition to keeping busy with activist work, Evelyn swims, walks and attends jazz concerts. She has never feared growing old; she believes that everyone should feel as free as possible from preconceptions of gender, race and age. She feels it is important not to be hemmed in by anyone else's philosophy; people should pursue their own dreams, to know the essence of their being — who they are, and who they were meant to be.

Eugene Kash *(with student Jordan Jackson)*

Violinist, conductor, teacher, father, grandfather, recipient of the Queen's Jubilee Medal and the City of Toronto Award of Merit. Born in 1912 in Toronto, Ontario, Canada.

Since he was five, Eugene Kash's life has revolved around music. Although his mother did not play an instrument, she loved music and passed on this love to him. His father did not influence him musically but he wanted his son to follow his passions and dreams, whatever they were. Eugene was especially fascinated by the sound of the violin, which came from a small "wooden box." Even at a young age, he loved playing and competing musically with his peers. Because of his hard work and musical talent, he very quickly became quite a good violinist. He studied with Luigi von Kunits, received a scholarship to the Curtis Institute in the United States and went to Europe to study and perform, making his debut in Vienna in 1932.

Eugene has had a varied career as a solo violinist and conductor, and has given both television and children's concerts. He has performed and recorded as a violinist around the world, including broadcasts with the BBC, the CBC and Radiodiffusion Française, and participated annually from 1961 to 1975 in the Casals Festival in Puerto Rico. He was musical director of the National Film Board of Canada in the 1940s, was concertmaster and then conductor of the Ottawa Philharmonic in the 1940s and 1950s, respectively, and held other conducting positions. He still teaches at the Royal Conservatory of Music in Toronto, where he has taught violin, viola and conducting to many students since his mentoring career began in 1974.

Teaching the younger generation how to apply themselves in developing the techniques they need to make music their form of expression gives Eugene great pleasure. He finds it key to teach them that the beauty of making music lies in one's ability to use it to move others. He also feels the importance of imparting to his students what he learned from his teachers, who learned from their teachers and so on, so that he is part of the chain between the great musicians and teachers of centuries past and the students of today. He enjoys being a senior because it gives him the ability and authority to pass on his knowledge to his students.

What continues to motivate Eugene is the fact that there is always another masterpiece to be reviewed, a new one to be learned; there is always another hill to climb.

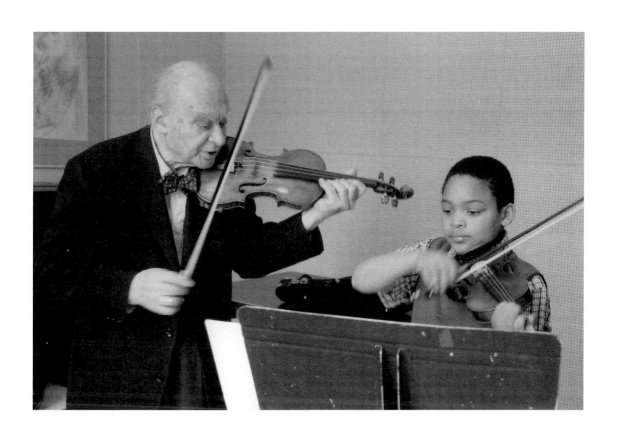

Beverley Borins

Collector and dealer of Inuit art, world traveler, lecturer, mother, grandmother.
Born in 1923 in Toronto, Ontario, Canada.

During her youth, in the Depression era, Beverley Borins' parents made certain their home was happy, loving, calm and fun-filled. Despite the difficult economic times, friends were always welcome.

In her early married years, Beverley stayed home to raise her family, the usual pattern in those days. As their three children grew older, Beverley's husband became ill and she took over the two hotels her family owned and managed. When that business was sold in 1970, she decided to start her own as an art dealer, since she had a talent for the arts and for making businesses work.

Beverley soon became enthralled by the work of aboriginal peoples, and particularly the art of the Inuit. After her first trip into the High Arctic, she became obsessed with the Inuit, whom she believes to be one of the strongest peoples on earth; despite the extreme hardships they endure, they are always willing to help one another. Inuit elders possess wisdom and values acquired not only through observation and experience, but also through an oral tradition passed down from generation to generation. Through her travels, Beverley has met many renowned carvers. She does everything possible to help promote aboriginal art.

Despite a couple of bouts with cancer, she engages in new plans and activities each day. Her rapport with her children and grandchildren is excellent; they look forward to being with her whenever possible, and listen eagerly to her many stories of the north. When she feels anxious or stressed, she loses herself in her many hobbies, such as sewing, beading, pottery, mosaics, and speaking about her interests.

Her years may be advancing, but Beverley still collects and sells art, always looking forward to the next discovery.

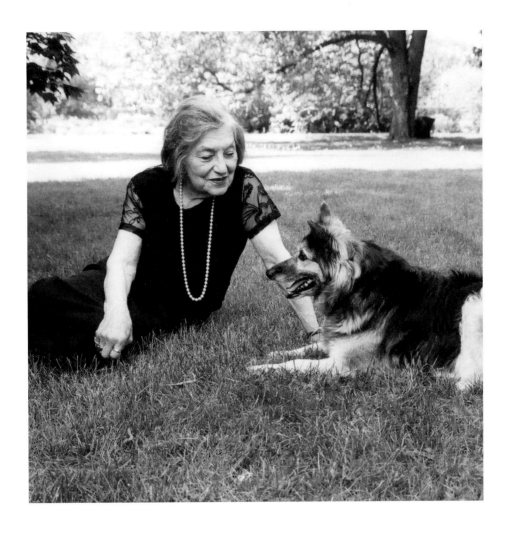

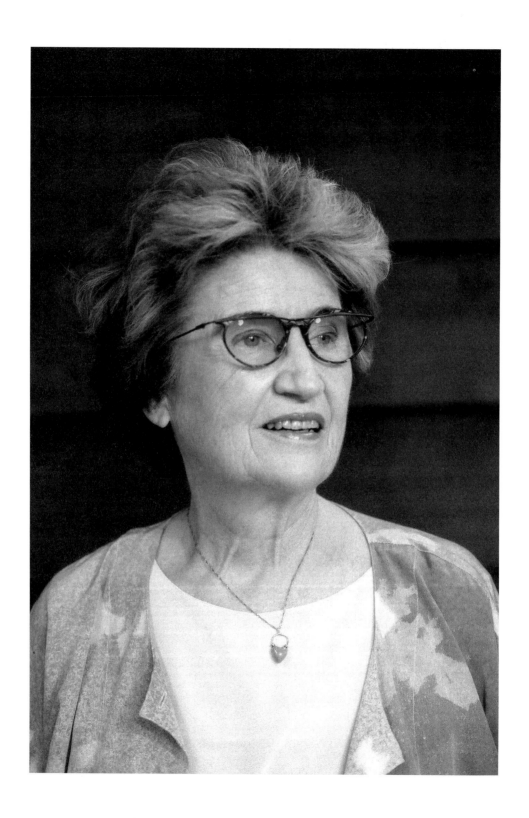

Elizabeth Jane McCready

Chaplain, nurse, pianist, poet, wife, mother, grandmother.
Born in 1929 in Toronto, Ontario, Canada.

Elizabeth McCready's father and mother were both influential in her choice of vocation. They were very positive role models, and gave her the strength and desire to help others. She worked as a nurse for many years, finding that "spiritual distress" was sometimes given as part of a patient's diagnosis. She began to explore her own spirituality in order to respond more effectively to patients experiencing spiritual crises, suffering and despair. When she left nursing in 1992, becoming a full-time chaplain seemed a natural extension of her former nursing role. She has been a specialist in pastoral care since 1998. Counseling other people and sharing the wisdom she has acquired over a lifetime has helped her feel that her own life has been blessed.

Elizabeth explains that "through the 'dark nights of the soul,' I have experienced considerable personal redemption. My motivation for ministry is to share with others what I have received in abundance through a lot of inner work and study." Other important influences in her life have been the exhilaration of life-long learning, and her awareness of herself, others and God.

There have been new challenges and new adventures along the way. When Elizabeth married her second husband, a widower, they brought together a large extended family. After she and her husband retired, they spent time working at a Canadian school in the south of France, he as a teacher, she as a nurse. Elizabeth also found new ways to give her time and energy to others; she has been a church organist and a volunteer. Throughout her life she has used poetry as a way of reflecting on her journey. She captures her philosophy in the final stanza of her poem "The Endless Beginning":

> *I reach toward the future, I let go of the past;*
> *I feel a sense of peace in my soul;*
> *The endless beginning changes scene and cast,*
> *I move on to learn my new role.*

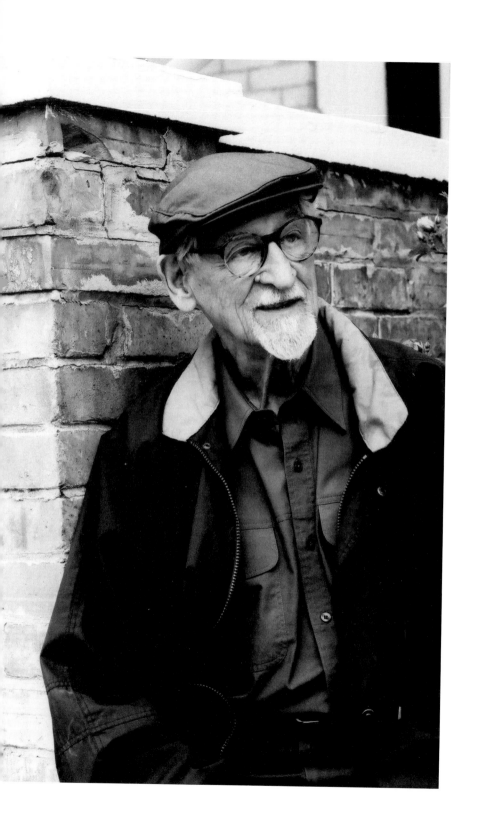

Jerome D. Diamond

Social worker, officer of the U.S. Corps of Engineers, advocate for emotionally disturbed youth, father, grandfather. Born in 1915 in New York, New York, U.S.A.

Jerome Diamond has always taken an active role in trying to improve the lives of others. He graduated from the University of Pennsylvania with a master's degree in social work in 1940, but very soon went into the military for five years, first as a clinical psychologist with the U.S. Air Force and then as an officer with the Corps of Engineers. He returned to his chosen field afterward, becoming the head of the Bronx Jewish Family and Child Services in 1956. He moved to Canada in 1959, and became the executive director of the Toronto Jewish Family and Child Services.

Jerome's experiences in counseling led to new ideas. Most adolescents with emotional and social problems had traditionally been treated in mental health asylums. But Jerome felt that if educators and psychiatrists worked together to provide a broader range of assistance, these troubled youths would be more likely to acquire not only the psychological treatment but also the skills they would need in order to function in society. In the late 1970s he founded the Jerome Diamond Centre in Toronto, providing such a combination of counseling and education for Jewish adolescents with emotional and social problems.

Jerome believes that each person has responsibilities and trials to face in life. He was married twice and both wives died of cancer after difficult illnesses. He feels his early religious education and social work training helped him to remain strong for his wives in spite of his own grief.

Jerome is not afraid of growing older, since this is a natural process; he sees it as a gift. As he ages, he continues to meet his commitments as honorably as possible. He has an excellent relationship with his three children. He remains physically active and was able to jog daily up until the age of eighty-five. He continues to help others through volunteering and through his general conduct – during a recent 36-hour blackout in his seniors' building he took a leadership role in helping his fellow residents deal with issues regarding food, water and lighting.

He believes that society needs to keep exploring ways to make use of the wisdom of aging people, and to let them contribute as best they can.

Peg Smith

Teacher, mother, grandmother, great-grandmother. Born in 1905 in Ottsville, Pennsylvania, U.S.A.

Peg Smith's father was a doctor and her mother was a teacher, so the family was very involved in the community. Peg was taught to place the interests of others above her own interests, and to "do for others" no matter how busy she might be. She was also taught to be outward-looking rather than inward-looking. As her parents were involved in helping, caring professions, it was natural for her to follow their example.

Peg taught high school English in New Jersey and Philadelphia until 1940, when she moved to Canada and married a widower with two teenaged boys. She became very involved with the YWCA, and also volunteered with the Public Welfare Council, the United Church of Canada, and the Toronto Public Library. She points out that people can maintain their interests and involvements as they age, but on a different level where necessary; for example, they may move from active work to advisory or consulting work.

Even as she approaches her hundredth birthday, Peg continues to live on her own. She observes that families tend to overprotect seniors. She believes that it is good for people to maintain responsibility and purpose as they age. Certainly her own independence is important to her.

Peg also observes that, when seniors are invited to family members' homes, they often feel they were asked because it was the right thing to do, and not for their value as people. Even though they are guests, the family does not really seem to expect them to contribute to the gathering. While they appreciate being invited, they are troubled to be regarded as an obligation. Peg believes that seniors have a lot of experience and stories to pass on, and that family functions can provide a good forum for such an exchange.

Peg has strong religious beliefs, which have helped her over some rough spots. Part of her belief system has taught her that no matter how busy you are, no matter how old you are, you can still find a way to do something for someone else.

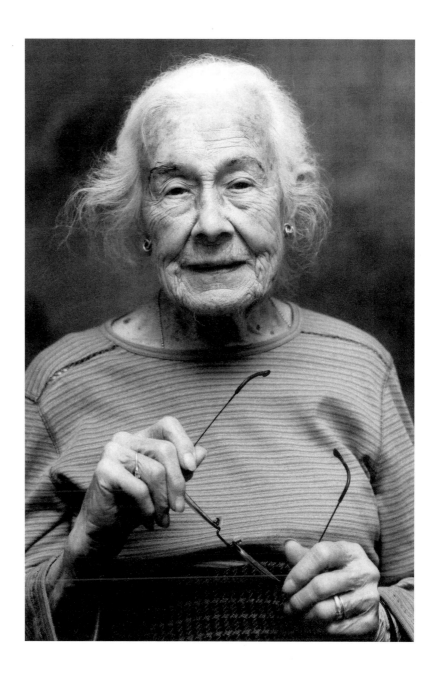

Jean Vanier

Philosopher and social visionary, author, Companion of the Order of Canada, member of the Legion of Honour (France), holder of the International Peace Award (Community of Christ), Pope Paul VI International Prize, Rabbi W. Gunther Plaut Humanitarian Award. Born in 1928 in Geneva, Switzerland.

Jean Vanier was born into a life of international service. His father, Georges Vanier, served Canada in many roles, both in Europe, as a minister and an ambassador, and at home, as governor general.

After naval service, Jean Vanier studied philosophy and theology in Paris. He taught at the University of Toronto. In 1964 he founded L'Arche (French for "the ark"), a community where men and women who have developmental disabilities and those who assist them create homes together. According to its charter, L'Arche wants to be "in solidarity with the poor of the world and with all who struggle for justice." L'Arche seeks to respond to the distress of those who are too often rejected, and to give them a valid place in society, a place where others can receive their gifts.

People who live at L'Arche are from a variety of religious and ethnic backgrounds. Today there are over 120 L'Arche communities in thirty countries on five continents.

In his book *Becoming Human*, Vanier wrote "All humans are sacred....Each of us has an instrument to bring to the vast orchestra of humanity, and each of us needs help to become all that we might be."

A man of deep and abiding faith, he believes in the transforming power of friendship and love: to reveal, to understand, to empower and to forgive.

FRANCIS MAURICE

An energetic octogenarian, Francis Maurice has been a member of L'Arche Daybreak since 1972. For over thirty years he has been offering his colorful paintings as gifts to visitors and members of Daybreak. His passion for bowling has taken him to many tournaments for Special Olympics. Participation in his Catholic church, where he is an usher and member of the Knights of Columbus, is a source of pride. For many years he worked at ARC industries, doing contract work and maintenance. Upon retirement he became a founding member of the Daybreak Seniors Club, where he delivers Meals on Wheels, makes cards, and enjoys bingo and bowling. Eight years ago he moved to a new Daybreak home where he has his own workbench — a retirement dream come true.

Francis is a great community person and is very faithful in keeping in touch with friends and family. His special gift for making children laugh has made him the adopted uncle and grandfather of many of his friends' children.

Francis Maurice

Retired maintenance man and bus shelter cleaner, newspaper deliverer, artist, woodworker and member of the Knights of Columbus. Born in 1922 in Ingersoll, Ontario, Canada.

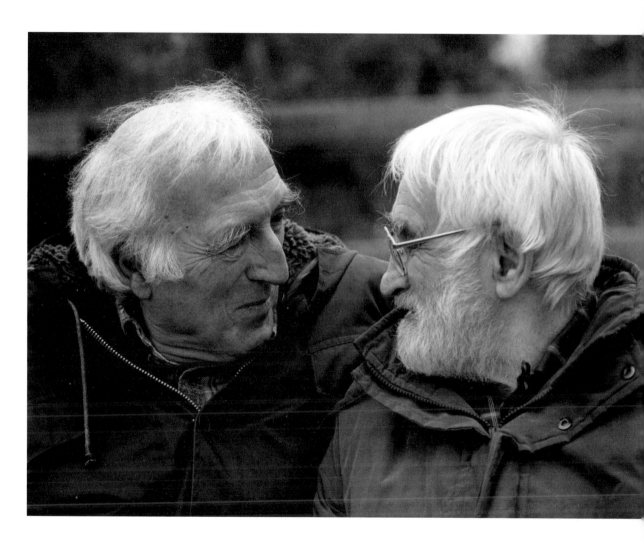

Nathan L. Leipciger

Consultant engineer, Holocaust survivor, recipient of the Meritorious Service Medal, lecturer, husband, father, grandfather. Born in 1928 in Chorzow, Poland.

Nathan Leipciger and his father survived Auschwitz, while the rest of the family perished. By the time he left the camp, the young man had lost his faith in God; how could he believe in a God that would let this happen?

Nathan immigrated to Canada, trying to move forward with his life. He was determined to attend university, but Jewish students had limited access to many courses. Furthermore, when he graduated from the University of Toronto with an engineering degree, he found that recruiters were reluctant to hire him, claiming that they did not discriminate but their clients did. Frustrated and discouraged, he eventually found a job with a small consulting engineering firm and started a family with his new wife.

Like many survivors, Nathan could not understand why he had survived while others, more learned, more pious, had perished. But his encounters with people who had retained their humanity through despair and deprivation gave him renewed hope, as did the acts of bravery and kindness by a very small minority of righteous people who had saved Jewish lives in the face of mortal danger. The Jewish philosopher Dr. Emil Fackenheim argued that "by abandoning Judaism and God, you are giving Hitler a posthumous victory, for this is what he wanted." This thought had a tremendous impact on Nathan, and he decided not to let Hitler destroy his spirit.

After years of silence about his experiences, Nathan hoped that by bearing witness to the horrors of the war years he could help younger generations understand that ignorance, fear and suspicion lead to xenophobia and hate — and that hate blinds the mind to acts of cruelty, brutality and murder. In 1975 he joined the Toronto Jewish Congress Holocaust Education Committee, and has since spoken at high schools and universities across Canada. He received the Meritorious Service Medal for his work to create a Holocaust Education and Commemoration Centre, and in 1990 became a representative on a council advising the Polish government on matters of preserving and commemorating Poland's six death camps.

In spite of his past suffering, Nathan remains optimistic. He devotes many hours and a great deal of energy to educating people. He believes that through education we can gain understanding and acceptance of others, no matter what their ethnic origin, religion or cultural background may be.

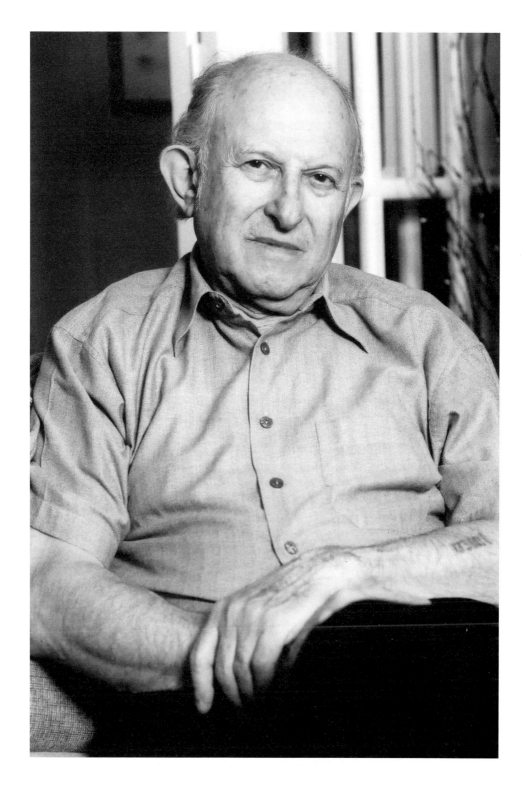

Norma Franks

Photographer, accountant, mother, grandmother. Born in 1924 in Toronto, Ontario, Canada.

Norma Franks remembers both her father and mother as being full of optimism and joy. Through their religious values and teachings, they guided her to have a positive attitude despite life's difficulties.

For years Norma has had a familial tremor — a neurological disorder that usually runs in families and that causes involuntary shaking, especially with purposeful movements. Her tremors are getting worse and she cannot write now, yet she does not see this as a problem; she accepts her situation and copes very well. She has learned that when you can't change a situation, you must make the best of what you have been given.

Norma has friends of all ages, and she often finds herself talking to younger people. She senses that when she laughs with younger people they stop seeing her as old, and they end up feeling good in her presence.

For twenty-five years Norma did accounting work. Now she appreciates having more time for other things, such as interior decorating. Two of her passions are gardening and photography. She feels that her strong sense of religion and her love for gardens have influenced her photography. Together they have helped create her way of seeing the world.

Norma combines her interest in photography with her enthusiasm for travelling. She has seen a great deal of the world — from Africa to South America to Asia — carrying her tripod with her everywhere. She has exhibited images from these trips, and also gives lectures and slide shows about her adventures. She enjoys sharing her knowledge of photography, particularly with her granddaughter. And she is already planning her next big trip... possibly a Pacific Ocean cruise, for a change.

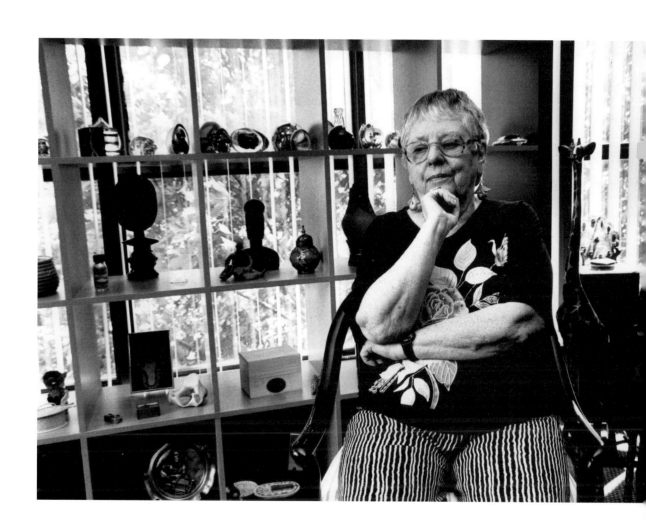

Harry Gairey

Construction surveyor, referee, coach, husband, father, grandfather.
Born in 1930 in Toronto, Ontario, Canada.

Harry Gairey's father was often away working on the railway, so Harry was raised primarily by his mother. He grew up in a working-class neighborhood that was very family-oriented. He mingled with people of all ethnic backgrounds – unlike what he observes currently, when he visits schools where different ethnic groups are segregating themselves and not interacting. He notes that when he was a child many of his close friends were Jewish; they understood what it was like to be discriminated against. He still maintains some of these friendships today. He feels that children, and many adults too, are missing the joy of making friends of different cultures and ethnicity by not mixing.

When Harry was a boy, he was barred from playing hockey because of his color. His father, Harry Ralph Gairey, led the fight against discrimination in the city of Toronto for seventy-five years, and finally the city council passed an ordinance requiring policies against discrimination on the basis of race, creed and color in all recreation and amusement establishments. Harry's father had incredible energy and vision, refusing to accept injustice, and he received the Order of Canada for his work in civil rights.

Harry followed in his father's footsteps. He has always been involved in community sports. In 2002 he was given the honor of having an annual basketball tournament in Toronto renamed "The Harry Gairey Girls' Invitational Basketball Tournament."

In addition to coaching and refereeing, Harry jogged, danced, and lifted weights to stay fit. In 1999 he suffered a heart attack, and has since modified his activities. But he remains very involved with family and community. Most important to him are his wife, child and grandchildren. He has friends of all ages, but many are older. He believes that it is especially easy to make friends with older people because after a certain age people tend to have similar interests, as their children are grown up and their work is not as important. In this way, age is a great equalizer.

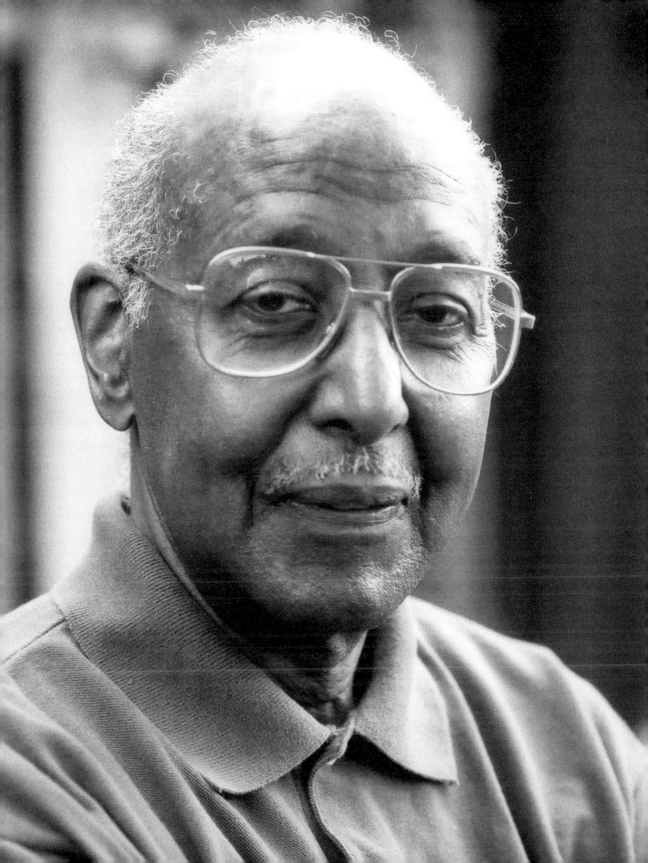

Sidney Katz

Writer, editor, professor, husband, father. Born in 1916 in Ottawa, Ontario, Canada.

Sidney Katz's most important personal relationship was with his mother, a courageous, forthright, deeply religious woman who raised a large family and had a keen interest in plant and animal life. She taught Sidney that there was a natural order of things: birth, growing, aging, death — the inevitable cycle of life. He believes that, for anyone with an understanding of science, the world is an awesome place.

Sidney's father was also a source of education and experience. A penniless immigrant with not a word of English, he overcame numerous challenges and established a place for himself and his children in his adopted country. Sidney acquired from his father the ability to face the problems presented by life and to deal with them constructively.

Another set of relationships and experiences arose from Sidney's wartime situation. For almost a year, he was part of a small group required to live in isolation in the sub-Arctic barrens. The weather was unforgiving; there were few comforts and his duties were arduous. However, he learned that all of us have within us the strength and character to triumph over privation, hardship, boredom and uncertainty when the situation demands.

Sidney has been a writer and journalist for many years, specializing in the field of health and human behavior and appearing in numerous publications, especially the *Toronto Star*. He has a master's degree in social work from the University of Toronto.

With age, Sidney has given up smoking and has become more health-conscious. He has learned to accept that he cannot now do what he could before, and he has let go of what needed to be let go. A cohesive family and warm, supportive friends have been extremely important to him and his wife, Dorothy, also a writer.

With advancing years, Sidney, like most people, takes a more personal interest in what writers and philosophers have observed about the process of growing old. Aristotle assured us that "education is the best provision for old age." The nineteenth-century writer Henri-Frédéric Amiel stated that "to know how to grow old is the masterwork of wisdom and one of the most difficult chapters in the art of living." Sidney has concluded that the relationships and experiences he encountered in his youth and early adulthood were good training for this "difficult chapter" in the art of living.

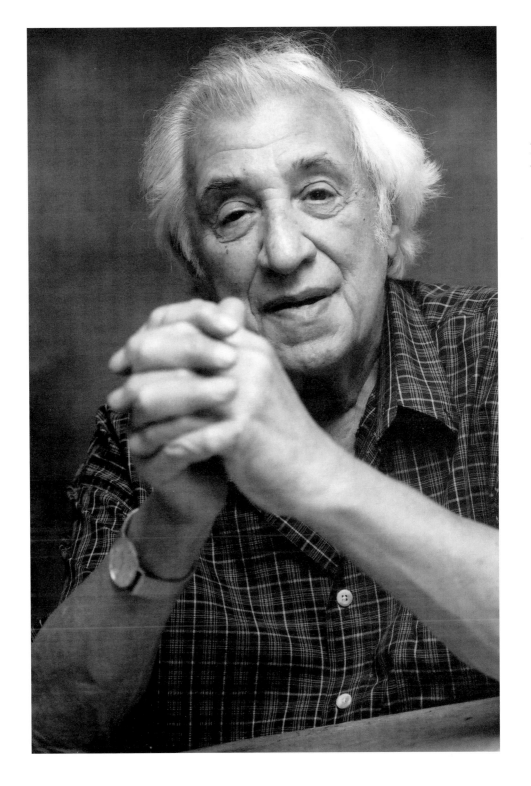

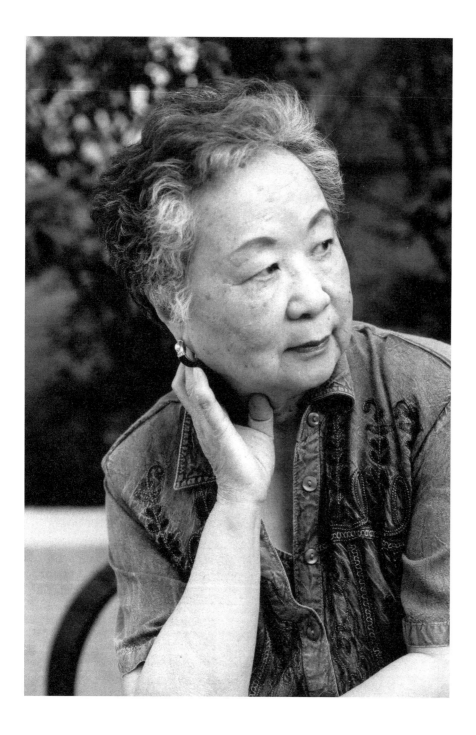

Connie Yang

General accountant, traveler, mother, grandmother. Born in 1930 in Shanghai, China.

Connie Yang came to Canada with her family in 1967, from Hong Kong. She worked as a general accountant until she retired at the age of sixty-five. Her husband died of cancer the next year and her mother died a month later. This was an extremely difficult time for Connie, and she feels that her belief in a higher power and her strong religious teachings helped her adjust to the losses. Her children were also a great consolation.

In appreciation for the help that Connie received during her husband's illness, she now volunteers at a hospital that treats people with cancer. She finds it very fulfilling to be able to talk to the patients individually, and feels that they have taught her a great deal about life. She laughs with them and sheds tears with them. She says, "This kind of mutual understanding is priceless."

In counseling patients at the hospital, Connie began to realize that many of them were still struggling with a lot of psychological pain from the past, quite apart from their present suffering. She feels the best remedy for dealing with this kind of old pain is to reach out — to comfort and be comforted through sharing. Rather than becoming depressed and angry over bad experiences in our past, we can make a choice to grow and flourish and give back to others. Connie believes that each of us has a mission to carry out before we end our journey, and she sees her counseling as one way that she can make her contribution.

Connie loves being a senior citizen, as she feels freer than when she was younger. She has time to give back to the society that accepted her and her family when they came from China, and wears her Canadian flag pin whenever she travels. She is an active member of the Older Women's Network, an advocacy and educational organization working on behalf of older women in Ontario, and is involved with other community groups. She sings in the church choir, and attends a seniors' oil painting class. Connie believes she is setting an example that will be a legacy to her three children and five grandchildren.

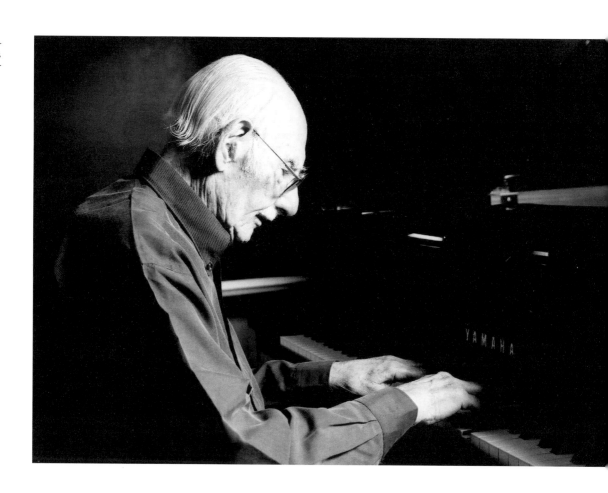

John Weinzweig

Composer, professor, Officer of the Order of Canada, recipient of the Order of Ontario and the Golden Jubilee Medal, husband, father, grandfather. Born in 1913 in Toronto, Ontario, Canada.

John Weinzweig's life was shaped by both his parents. He was influenced by his mother creatively: although she was not educated – the norm in Poland during her childhood – she admired her twin brother, who was a poet. She believed that when people are young they should learn as much as they can. As for John's father, he was active politically, to the point of being jailed in Poland for his socialist beliefs.

John was born in Toronto. He graduated from the University of Toronto and studied further at the Eastman School of Music in Rochester, New York. He has distinguished himself as a composer of international renown, and as an educator and mentor to many of Canada's foremost composers. His best-known works include a ballet suite, *Red Ear of Corn*, and the series *Divertimenti*. He is also the founder of the Canadian League of Composers and has contributed to many other musical organizations. His colleagues in Canada see him as a dedicated champion of twentieth-century Canadian music, and he has their respect for both his compositions and his leadership.

John swims weekly at a University of Toronto pool, and he walks rather than taking the subway. He believes it's important to keep moving. Despite various health problems, he continues to create, as this has been a lifelong passion. In his compositions, he responds to the environment, to events and to the world around him, because he feels it is vital to be involved in the events of our time. He is also inspired by his wife, Helen, a novelist.

John has never had any fear of aging, accepting it as inevitable. As long as his mind is working, he is happy. He was somewhat surprised to find himself turning ninety, but he continues to practice, compose and perform. He believes he has gained dignity with age, and certainly has no regrets about anything he has done during his life so far.

June Callwood

Author, journalist, broadcaster, Companion to the Order of Canada, recipient of the Order of Ontario, member of the Canadian News Hall of Fame, social activist, speaker, wife, mother, grandmother. Born in 1924 in Chatham, Ontario, Canada.

June Callwood was raised in an unstable family, with her father mostly absent and her mother emotionally distant. However, her grandparents, especially her paternal grandfather, showed great faith in her abilities even at a young age. Their faith gave her confidence to do anything she desired, even though the society she grew up in did not value the ability of women. Her confidence also allowed her to become a fearless and outspoken crusader for social causes.

June was a bright student but she felt like an outsider and had trouble fitting in. She left high school early and got a reporting job at a small newspaper, where she learned the basics. Joining a large Toronto newspaper in 1942, she reported on leading stories, even spending a night in jail following a peace demonstration. She married a fellow reporter, Trent Frayne, in 1944, but retained her maiden name because the newspaper's policy required married women to resign.

While raising their four children, she turned to freelance magazine writing and eventually to books. She is the author of some thirty books, about half of them ghostwritten for others. Her career as a journalist and author is still going strong after more than sixty years.

She has also been founder or co-founder of more than fifty social action organizations.

As an outgrowth of journalism, June appeared on radio and television as a host and interviewer, starting in the mid-1950s. The programs dealt with issues dear to her heart, such as people whose lives reflect a sense of responsibility to others, and caregiving for parents, spouses and others. She explains one of her reasons for broadcasting even after reaching her late sixties in a quote from the introduction to her book *June Callwood's National Treasures*: "I rejoiced in the opportunity to show the wrinkled face of a truly old woman. An aged man who hosts a television show is considered distinguished, but an aged woman seems to invite derision. Old women appear on television mainly as props in commercials about tea or dentures. I hoped my weathered face and sagging jawline would make it easier for other old women to surmount the barriers."

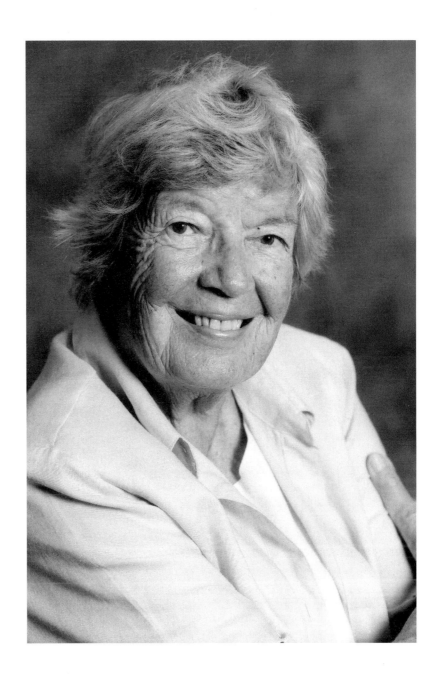

IRENE BORINS ASH

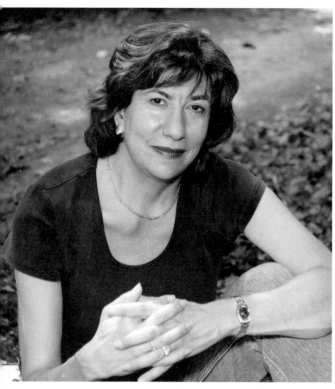

Gadi Hoz Photographies Inc.

Irene Borins Ash is a consultant and a speaker specializing in helping seniors develop a healthy attitude toward aging. She is a Registered Social Worker with a Master of Social Work, and has been on staff at several health care facilities and presented papers across the country. An amateur photographer, Irene has exhibited her work at various galleries and at Toronto's city hall. She lives in Toronto with her husband.